NEW ORLEANS

THEN AND NOW®

First published in the United Kingdom in 2018 by
PAVILION BOOKS
an imprint of Pavilion Books Company Ltd.
43 Great Ormond Street, London WC1N 3HZ, UK

"Then and Now" is a registered trademark of Salamander
Books Limited, a division of Pavilion Books Group.

This book is a shortened, revised version of the original *New
Orleans Then and Now* by Sharon Keating first produced
in 2010 by Salamander Books, a division of Pavilion Books
Group.

All notations of errors or omissions should be addressed to
Salamander Books, 43 Great Ormond Street, London WC1N
3HZ, UK.

ISBN-13: 978-1-911595-89-2

Printed in China

10 9 8 7 6 5 4 3 2 1

AUTHOR ACKNOWLEDGMENTS
I would like to acknowledge my husband, Wayne, the
New Orleans Public Library and the Historic New Orleans
Collection for their help with this book.

PICTURE CREDITS
The publisher wishes to thank the following for kindly
supplying the photographs that appear in this book:

All "Then" images in the book were supplied courtesy of
Library of Congress, except for the following: Corbis/Getty
Images p.50, p.56, p.62 and p.76.
All "Now" images: Frank Hopkinson/Pavilion Image Library.

NEW ORLEANS
THEN AND NOW®

SHARON KEATING

PAVILION

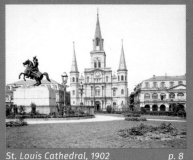
St. Louis Cathedral, 1902 p. 8

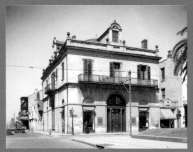
Louisiana State Bank Building, 1936 p. 20

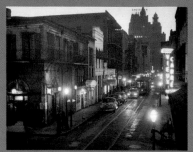
Bourbon Street, 1946 p. 24

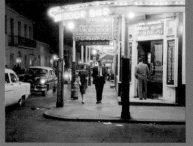
The Famous Door, 1959 p. 28

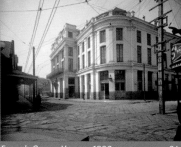
French Opera House, 1890 p. 34

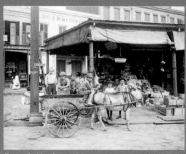
French Market, 1910 p. 46

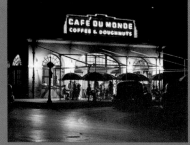
Café du Monde, c. 1940 p. 50

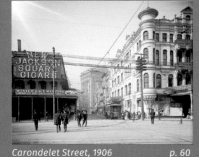
Carondelet Street, 1906 p. 60

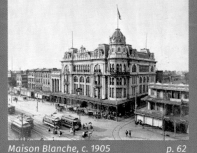
Maison Blanche, c. 1905 p. 62

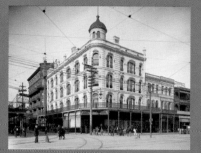
Chess, Checkers & Whist Club, 1905 p. 64

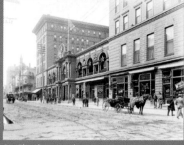
St. Charles Hotel, 1900 p. 72

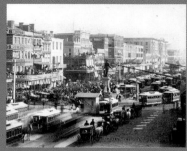
Canal Street, c. 1890 p. 76

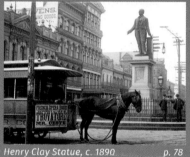
Henry Clay Statue, c. 1890 p. 78

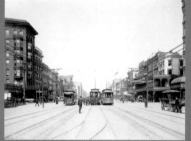
Streetcars on Canal Street, c. 1905 p. 80

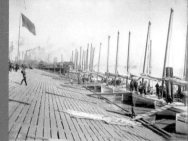
Oyster Luggers, 1901 p. 86

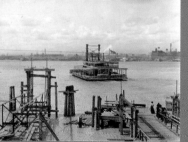
Algiers Ferry Landing, c. 1900 p. 88

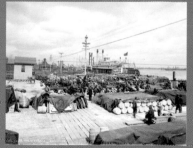
Levee at foot of Canal Street, 1900 p. 90

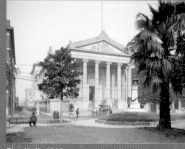
City Hall, 1910 p. 94

The city of New Orleans occupies a singular place in the soul of the American nation. Born in a most inhospitable setting on the Mississippi River in the eighteenth century, it was sired by the French, mentored by the Spanish, and finally bought by the United States. The River is the city's defining feature. Its location as a major port is its underlying *raison d'être* and helps explain its history as the most culturally diverse city in the South.

New Orleans has usually been portrayed as a Southern city. However, it is apparent to anyone who visits that this city's location in the Deep South has informed, but not dominated, its culture. The Europeans who settled here became known as Creoles, along with the generations following. The remnants of the French and Spanish legacies are deeply ingrained in the language and customs. Thus, there are banquettes instead of sidewalks. Most of Spain's legacy is visible in the architecture of the French Quarter, or as it is known by its French name, the Vieux Carré, as the Spanish rebuilt much of this section after several fires destroyed the earlier buildings. The Louisiana State Museum is in the Cabildo, and was originally built by the Spanish to serve as the capitol.

The rich fusion of traditions is not confined to those earlier settlers. African slaves, a number of whom were able to buy their freedom, contributed their lush heritage to the mélange. Haitians fleeing after the slave revolts in that country also became *les gens de couleur libres*, free persons of color, and their descendants were also Creoles, sometimes called Creoles of Color. Native Americans developed relationships and intermingled with both the Europeans and the people of color. All of these groups combined resulted in a population unlike any other, even unique within the state of Louisiana itself.

When it was purchased by the United States, Louisiana— and New Orleans in particular—truly appeared to be

NEW ORLEANS
THEN AND NOW INTRODUCTION

a foreign country. Unlike the rest of the nation, it was predominantly Catholic and the major language was still French. Customs ordinary to New Orleans, such as quadroon halls and the practices of voodoo religion, were exotic. Due to its location as a large port, immigrants from all over the world settled here, and Italian, Irish, German, and many other peoples have added spice to what has become the sound and flavor of the city.

For a while, the culture clash with the Americans became too much for the Creoles, and different sectors of the city were formed. The Garden District became home to the rich Americans while the Creoles continued to live on the other side of Canal Street. The only mingling between them was for the necessary evil of doing business. Today, the streets on the Creole side of Canal have maintained their French names, such as Chartres and Decatur, while on the other side, those same streets have "American" names such as Camp and Magazine.

New Orleans is a Southern city, but it is not only moonlight and magnolias, sweet tea or mint juleps, although you can find all of that here. It is not only Bourbon Street or Frenchman Street, although they still remain primary tourist destinations with many great bars and restaurants. It is also a place of history, full of trials and tribulations. During the Civil War, "the Queen of the South" and its position as a river port was a prime target for the Union army. Under Union occupation, New Orleans never bowed its head, but chose to snub the invading Yankees rather than recognize them.

This has always been a place of contrast. In its career, New Orleans has been home to wealthy Creoles, has quartered bayou pirates, has given refuge to riverboat gamblers, and has housed sugar barons. At least one voodoo queen is buried in a Catholic cemetery, and most New Orleanians do not find this strange. It is accepted fact that there would be no Mardi Gras for the sinners if there were no Lent for the saints, so the one necessarily makes room for the other.

From the Caribbean through the port came the devastating yellow fever in the nineteenth and early twentieth centuries. The once proud Pontalba buildings had become slums for the newly arrived immigrants, and a breeding ground for the epidemic. The subtropical climate allowed the virus to flourish, decimating the population. Those who could afford to leave did so during the summer months. Eventually, drainage was improved, helping to quell more epidemics. The Pontalba buildings are once again choice real estate in the French Quarter.

New Orleans has been harassed by hurricanes, flooded, and nearly destroyed by the levee failures. In the aftermath of Hurricane Katrina, the general spirit of the city was shaken but, as a whole, it was never broken. It didn't occur to most New Orleanians that there should be no Mardi Gras or Jazz Fest. The motto continued to be *Laissez les bon temps rouler*, or "let the good times roll." Then, more than ever, the city chose to celebrate life even as it mourned its losses.

New Orleans has been lovingly rebuilt by humanitarians from all over the world, some of whom have added their own zest and expanded the culture yet again. For this, the city is profoundly grateful. Her landscape may be evolving but her essence remains the same—and the music and food are like nowhere else on the planet. There are now more places to eat than before Hurricane Katrina. Outdoor concerts and sidewalk musicians abound. Music is everywhere, whatever your taste may be. The pictures change but the traditions remain as always, spiritual and earthly, pious and profane, troubled yet joyous.

Welcome to New Orleans.

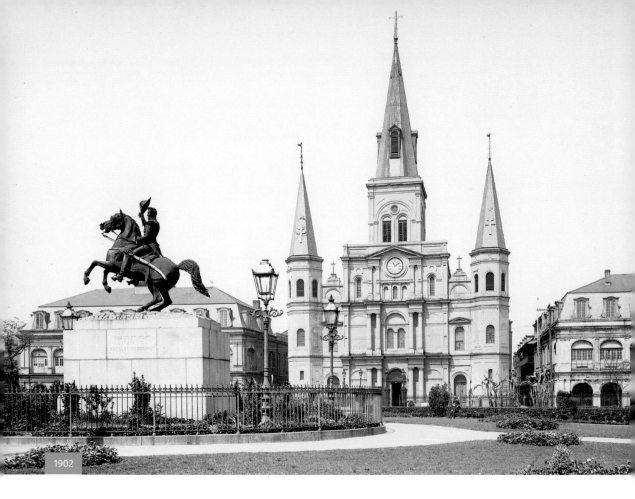

1902

JACKSON MONUMENT AND ST. LOUIS CATHEDRAL
The square at the heart of New Orleans

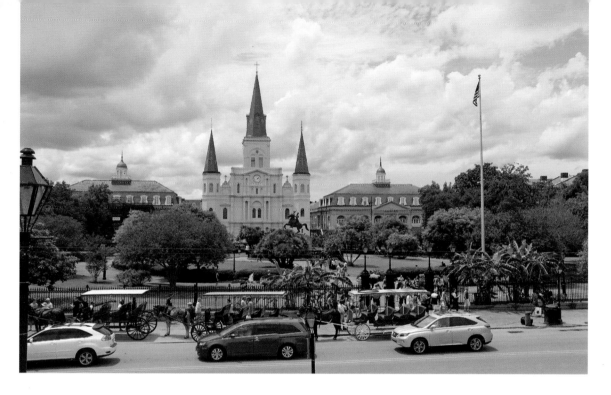

LEFT: This beautiful square has always been a public space since the founding of New Orleans. In 1718 Jean-Baptiste Le Moyne, Sieur de Bienville, chose this spot at the head of one of the crescents of the Mississippi River to establish New Orleans. This square was the central element of a city plan laid out by Adrien de Pauger in 1721. Originally the Place d'Armes, it became the Plaza de Armas under Spanish rule, but the Creoles called it the Place Publique and the Americans called it the Public Square. It wasn't until 1851—when the statue of General Andrew Jackson was erected—that it became Jackson Square.

ABOVE: The Baroness Micaela Almonester de Pontalba designed and built the two apartment buildings flanking the square and was responsible for refurbishing the square itself. Today the Pontalba Apartments are thought to be the oldest apartment buildings in the United States. Jackson Square remains the center of New Orleans. The city grew out and around it. Today it's a place where locals and tourists alike enjoy the artists, palm readers, street musicians, and entertainers that surround the square. The St. Louis Cathedral sits just outside of the square between the Cabildo and the Presbytère.

THE CABILDO
The seat of colonial power when the city was ruled by Spain

BELOW: The Cabildo, erected during Spanish rule, was used as the seat of administration for the entire province of Louisiana. It also housed both civil and criminal law courts. Spanish officials would use the second-floor balcony to view ceremonies, parades, and militia drills. The Cabildo was the site of the transfer of Louisiana from Spain to France in November 1803. Just twenty days later, France sold Louisiana along with considerably more land to the United States in the Louisiana Purchase. Dignitaries from the three nations officially met and concluded the transfer of land in this building.

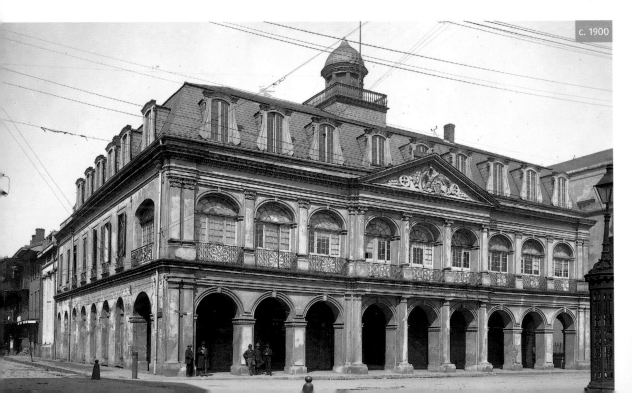

c. 1900

BELOW: The Cabildo was turned over to the Louisiana State Museum in 1914 and is still in use as a museum today. It houses memorabilia from two centuries of New Orleans history and has been visited by five U.S. presidents. Most of the original structure had been destroyed in the Good Friday fire of 1794. It is separated from the St. Louis Cathedral by Pirate's Alley. According to legend, it was in this alley that Jean Lafitte and his privateers joined with the Americans to plan the British defeat in the Battle of New Orleans during the War of 1812. Also in this alley is the former small home of the great American author William Faulkner, which is now used as a bookstore.

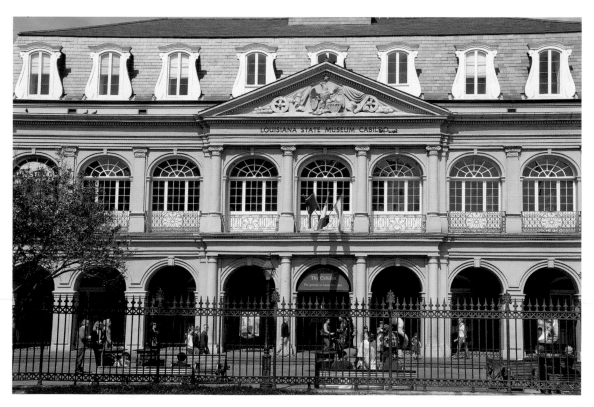

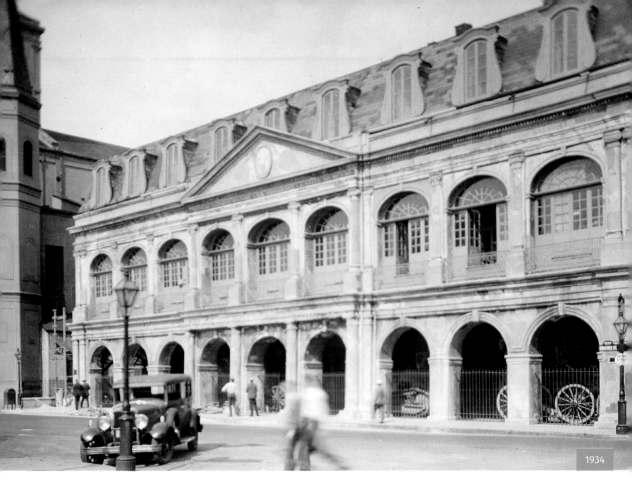

1934

PRESBYTÈRE

Gifted by the man who financed the Cabildo and the St. Louis Cathedral

12

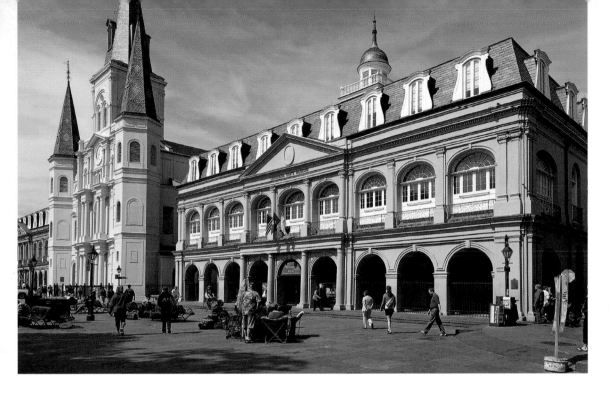

LEFT: This photo shows the Presbytère, or "Priest House," in 1934. The Presbytère was built on the site of a former Capuchin monastery. Although it was intended to be used as a rectory, it never saw out that purpose. Construction began in 1791, and it was designed to match the Cabildo on the opposite side of the cathedral. In 1813 the second floor was added. The Presbytère was used as commercial space until 1834, when it became the home of the Louisiana Supreme Court. In 1847 the facade of the structure was changed with the addition of the mansard roof. It was sold to the city in 1908 and to the State of Louisiana in 1911.

ABOVE: Since the transfer to the State of Louisiana it has been used as a museum. Today it contains a large collection of Mardi Gras gowns and memorabilia in a much-visited exhibit. The alley between the cathedral and the Presbytère is named for one of the most beloved priests in New Orleans history, Pere Antoine. In 1970 the Presbytère was added to the National Register of Historic Places. The cupola was lost in a hurricane in 1915, but was eventually replaced in 2005. Don Andres Almonester y Roxas, the philanthropist who financed the Presbytère, the Cabildo, and the St. Louis Cathedral, is buried in the cathedral.

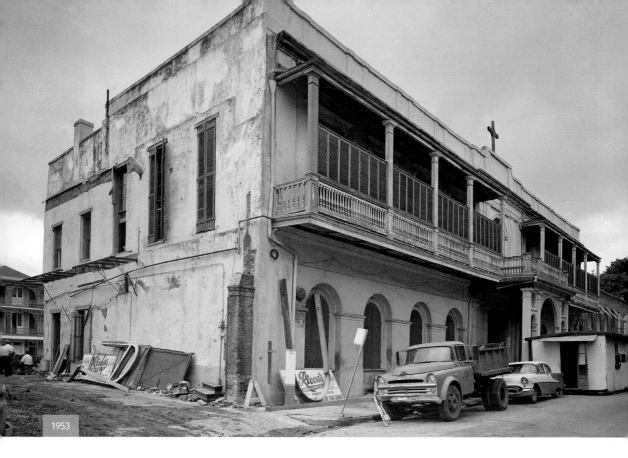

1953

ORLEANS BALLROOM / BOURBON ORLEANS HOTEL

The building at 717 Orleans Street has been a school, a ballroom, and a hotel

ABOVE: This photo shows one of the few remaining buildings in which the quadroon balls—where white gentlemen would rendezvous with the quadroon girls—were held. Quadroons were the offspring of white fathers and mixed mothers. Mixed-race dances became legal in 1799, and these ballrooms were the meeting places that

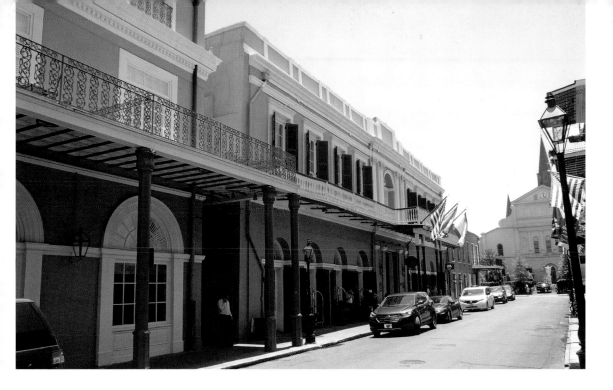

often resulted in unique social arrangements that lasted many years. After a match was made, the gentleman would provide a home for the quadroon, and any children born of these unions were automatically free at birth. This large population of free people of color was unique to New Orleans in the 1800s. Often, to make additional money, the quadroons would set up boardinghouses in their homes for the many men who came into New Orleans on the river. In 1881 the Sisters of Holy Family established a school for young black and mixed race girls in this building that lasted until the 1960s.

ABOVE: Much of New Orleans's reputation for fine cuisine can be traced to the competition among the quadroons to offer the finest meals to their boarders. Since the 1960s, the building at 717 Orleans Street, behind the St. Louis Cathedral Garden, has been used as a hotel. It currently houses the Bourbon Orleans Hotel, a beautifully restored European-style hotel offering suites with balconies overlooking Bourbon Street or the St. Louis Cathedral Garden. Orleans Street is much wider than most of the streets in the Vieux Carré as it emerges from the beautiful St. Louis Cathedral Garden.

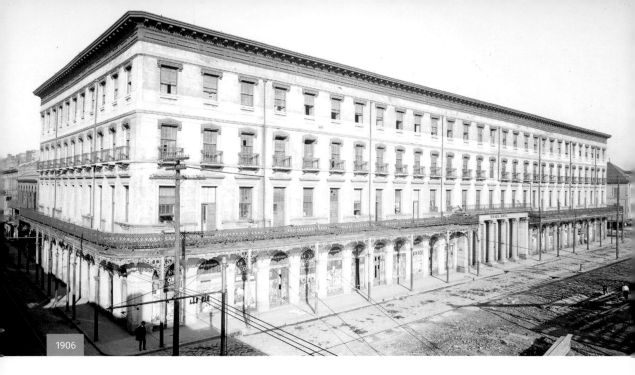
1906

ST. LOUIS HOTEL

Considered the grandest hotel outside of Paris, it once held slave auctions

ABOVE: The St. Louis Exchange Hotel, which bore the name of the patron saint of New Orleans, was completed in 1838. It was considered to be the grandest hotel outside of Paris. The hotel had a rotunda that was sixty-six feet in diameter and paved with colored marble. It also had a copper-plated dome said to weigh 100 tons. The rotunda was used as an auction place for all commodities coming into the port of New Orleans, including slaves. In 1841 it was destroyed by fire, but rebuilt and later renamed Hotel Royal. The Americans, wishing to compete with the St. Louis Hotel, built the lavish St. Charles Hotel in the American sector of the city at about the same time. By the time Mark Twain visited in 1882, it had already been turned into "municipal offices." By the time this photo was taken, the building had fallen into neglect and decay.

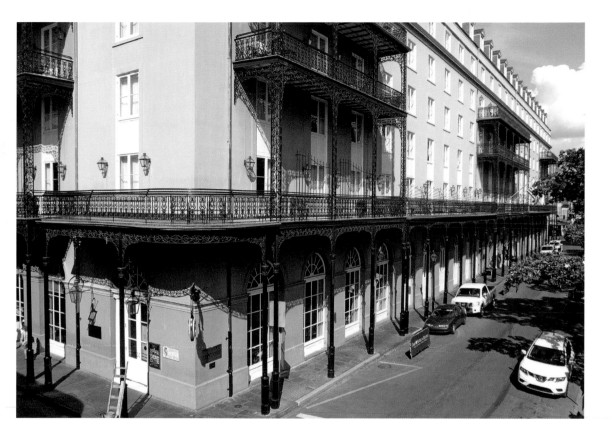

ABOVE: When the St. Louis Hotel building was eventually torn down in 1915 after being partially destroyed by a hurricane, the incredible murals that covered the walls were purchased by France. Since 1960 the Royal Orleans Hotel, now the Omni Royal Orleans, has occupied this site on St. Louis Street between Royal and Chartres streets. The arches on the Chartres side of the hotel are from the old St. Louis Hotel and include a portion of the slave auction block originally located inside the rotunda.

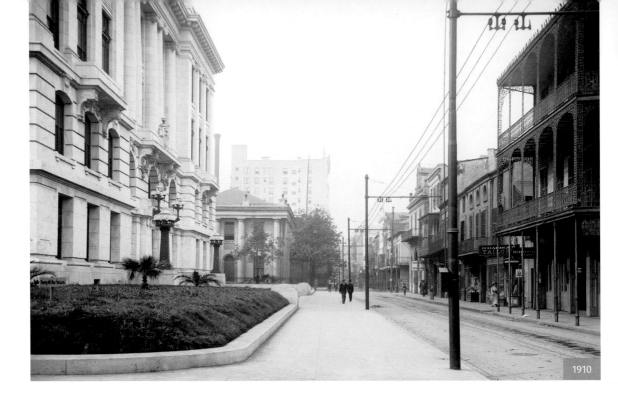

1910

SUPREME COURT BUILDING
Considered a monstrosity when it was first imposed on the French Quarter

ABOVE: This photo, taken shortly after the building was completed, shows what is perhaps the most controversial structure in the French Quarter. Built in 1910 as the "new courthouse," the plan had been to tear down slums and replace the Cabildo and the Presbytère with a new home for the judicial system of New Orleans. Unfortunately, the so-called slums torn down on the site of the new courthouse were nineteenth-century Creole houses that were in disrepair, yet still historically significant. The new courthouse, a huge Beaux-Arts building, was considered by many to be a monstrosity, completely out of scale with the area.

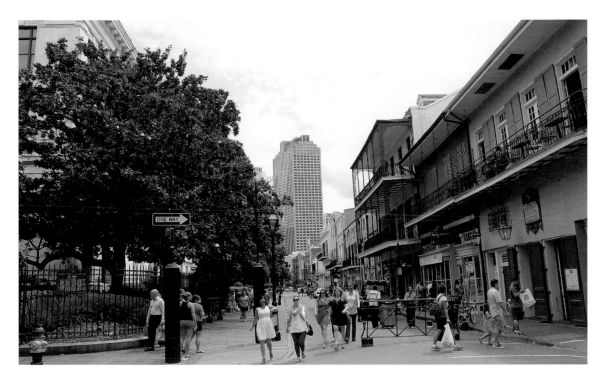

ABOVE: The courthouse was abandoned in 1958 when the courts moved to a new location. The State Agency of Wildlife and Fisheries took over the building for some time. When that agency moved out, the building went into disrepair. After years as home to the Louisiana Wildlife and Fisheries in New Orleans, the courthouse has been restored to its former glory and again houses the Louisiana Supreme Court and the Fourth Circuit Court of Appeal for Louisiana. A statue of Edward Douglass White, the only United States Supreme Court justice from Louisiana, who served from 1910 to 1921, stands in front of the building. It is now an accepted part of the French Quarter, and the verdant lawns and landscaping around the building have helped to soften the size of the large structure. The interior marble floors and stairs make for an elegant space that also houses the Louisiana Law Library and the Louisiana attorney general's office.

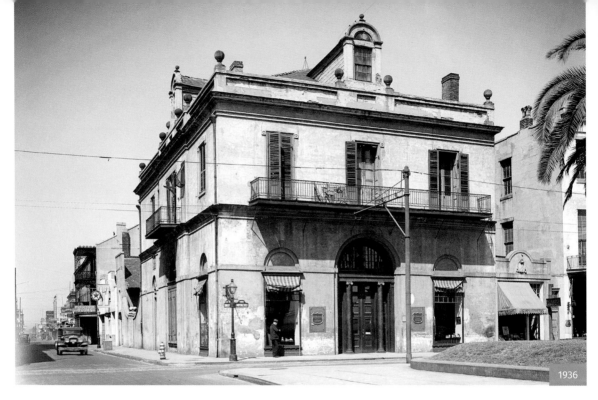

1936

LOUISIANA STATE BANK BUILDING
The final commission of architect Benjamin Henry Latrobe

ABOVE: British architect Benjamin Henry Latrobe had designed the New Orleans U.S. Custom House of 1807 and returned to finish off the water works, which had halted after the premature death of his architect son. His plan for the State Bank of Louisiana was accepted on August 10, 1820, and he died in a yellow fever epidemic twenty-four days later. The building, erected for $55,000 at Royal and Conti streets, was at the hub of New Orleans's financial center. Diagonally opposite, at 334 Royal Street, was the Bank of Louisiana, and further along Royal was the Citizen's State Bank, which issued its own grand $10 note with the French word *dix* (ten), thought to be the origin of the words Dixie and Dixieland. The bank traded until 1870. After that it became a furniture storehouse.

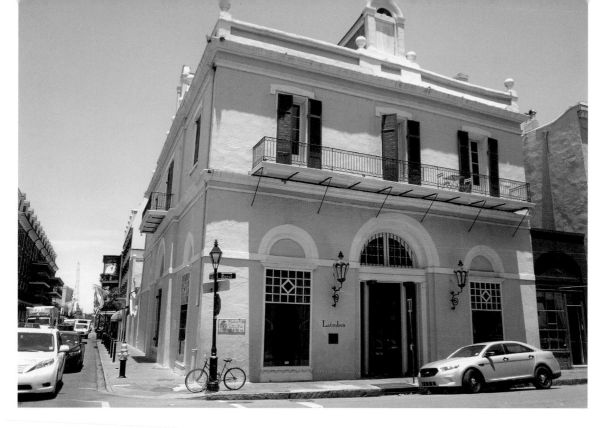

ABOVE: For most of the twentieth century the building was occupied by cabinet maker and antique dealer Bernard Manheim who opened his first shop in 1919 a few doors away at 409 Royal Street. Manheim Galleries became an internationally known business and success allowed the family to take over the old bank building at 403 Royal. In 1983 Benjamin Henry Latrobe's last major building was listed in the National Register of Historic Places. In 2014 it was acquired by Hotel Monteleone and restored to its original grandeur. Aptly named Latrobe's On Royal, today it is an elegant venue for weddings and other events, and has retained many of its original features, including the bank vaults. The Bank of Louisiana building, which is still diagonally opposite, lost its charter in 1867. Today it is a police substation and tourist information center.

NAPOLEON HOUSE

Still waiting for the scourge of Europe to escape from St. Helena

c. 1900

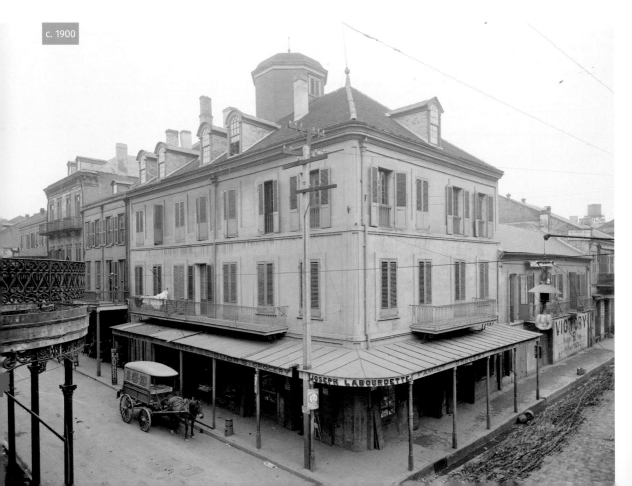

LEFT: The Napoleon House was constructed in 1794 and was owned by Claude Girod. Claude and his brother Nicholas conducted business on the first floor. Nicholas Girod, who became mayor of New Orleans, built the cupola on top so he could watch the Mississippi River for his ships coming into the port. The legend of this house is that when Napoleon was exiled, Mayor Girod planned to launch a rescue mission and build a refuge for Napoleon in this house should it succeed. This legend has never been proven as historically accurate, but it was sufficient to change the name of the house.

BELOW: The Napoleon House is considered to be one of the best surviving examples of French architecture in the Vieux Carré and has been designated as a National Historic Landmark. The Impastato family has owned the Napoleon House since 1914 and operates the world-famous Napoleon House Bar on the first floor. The bar, named by *Esquire* magazine as one of the top 100 bars in America, plays classical music and serves food and beverages, but is most famous for the Pimm's Cup, a refreshing liqueur-based drink served on the rocks with a slice of cucumber.

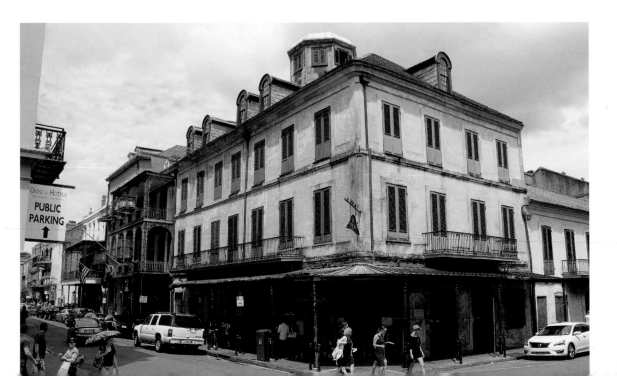

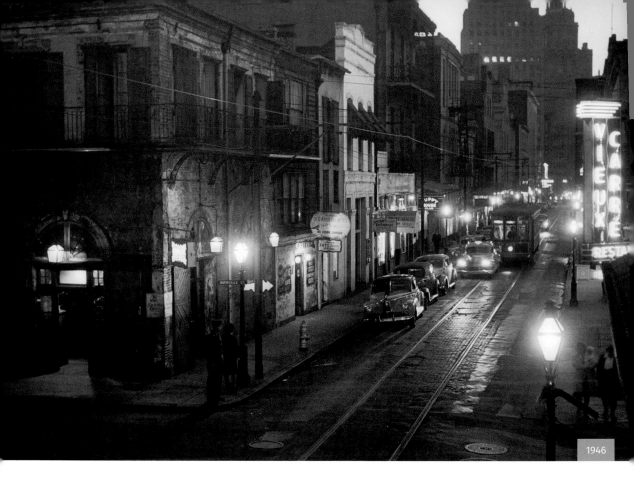

1946

BOURBON STREET

The most famous street in New Orleans and the center of many celebrations

ABOVE: Contrary to popular belief, Bourbon Street was not named for the alcoholic beverage. It was named—like many of the streets in the Vieux Carré—for one of the royal houses of France, the house of Bourbon, which was

24

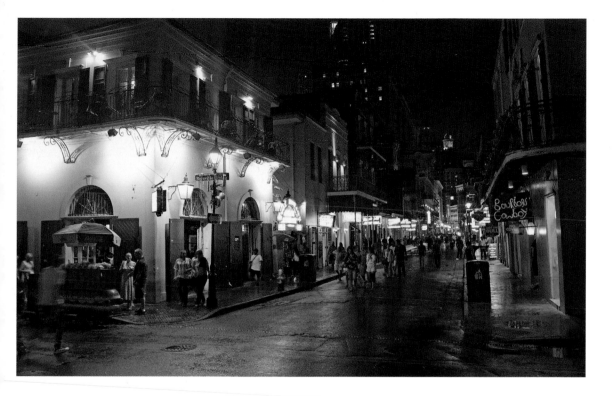

the ruling house of France at the time New Orleans was planned. The original name of this street was Rue Bourbon. When the Americans took over in 1803, all "Rues" were changed to "Streets." In the early twentieth century, jazz clubs and bawdy vaudeville theaters sprang up along Bourbon Street. By the 1940s, Bourbon Street added neon lights and nightclubs featuring burlesque shows, as shown in this photo. Its reputation was sealed.

ABOVE: Bourbon Street is the most famous street in the French Quarter, if not in all of New Orleans. Street parties for Mardi Gras, the Jazz Fest, the French Quarter Festival, the Super Bowl, the Sugar Bowl, or just because it's Tuesday are well known around the world. Bourbon Street has more than just bars and nightclubs; it also has fine restaurants and hotels. Yet, it's still only one street in one section of one great city.

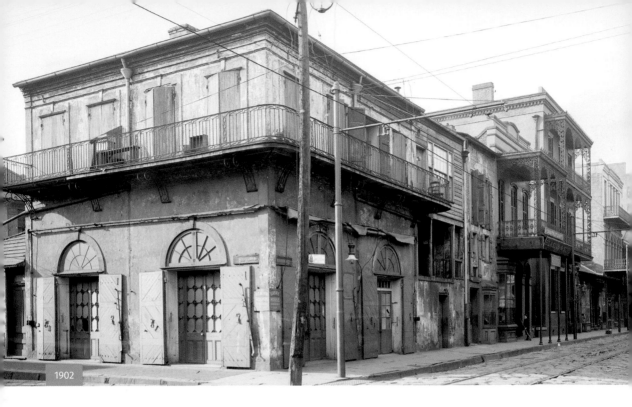

1902

OLD ABSINTHE HOUSE
A rare building that employs Spanish Colonial architecture, popular in Cuba

ABOVE: The Old Absinthe House on the corner of Bourbon and Bienville streets in the French Quarter was built in 1806 by two Spanish traders as a home for their import business. It became a tavern shortly afterward. It is one of a handful of entresol buildings in New Orleans. Entresol buildings usually combined a retail establishment on the ground level, a residence on the top, and a hidden floor in between for the storage of goods. The building got its name in 1874 when a mixologist from Barcelona created a drink using absinthe, a narcotic-like spirit. Absinthe became illegal in 1912 and was replaced by Herbsaint in the mix.

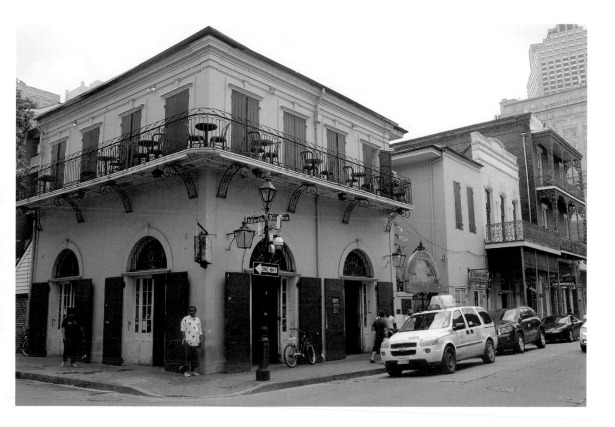

ABOVE: In the late 1950s, the midfloor entresol was removed to create a higher ceiling for the first-floor bar. The building is now divided into three spaces. Two are used for restaurants; but there is still a bar located on the corner of Bourbon and Bienville, as it has been for the last 200 years. No visit to New Orleans is complete without a trip into the Old Absinthe House. Up until the 1960s the streetcar named Desire, made famous by Tennessee Williams in his play, ran down Bourbon Street and stopped at this corner. Today, the streetcar tracks are gone, but the atmosphere, history, and maybe even the odd ghost remain.

THE FAMOUS DOOR

Club manager "Hyp" Guinle put a list of his top acts by the door

BELOW: The building at 339 Bourbon Street dates from 1826 and was built by Frenchman Don Andre Guillory. Prior to 1934 it housed a pharmacy before Hypolite "Hyp" Guinle leased the building for $50 a month and opened the Famous Door club as a music venue. The Door wasn't so famous at first but gained its name after Hyp asked visiting celebrities to sign the guest book. He declared the corner of Bourbon and Conti the "Jazz Corner of America"

and erected plaques either side of the door with the names of the famous jazz musicians who had played there, including George Girard and Louis Armstrong. Hyp ran the club for over thirty years, until his death in 1965. His widow, Genevieve, continued his musical legacy for another eight years until 1973 when she sold the property to local club owner Nick Karno.

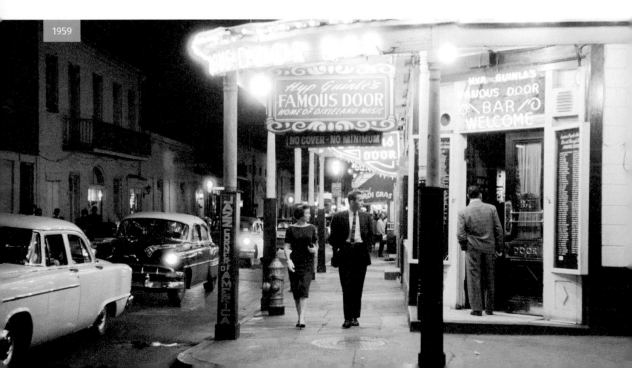

1959

BELOW: The Karno family had many businesses along Bourbon Street. Nick Karno had bought the 500 Club across the street from the Prima Brothers in the late 1950s and his son Louis remembers being allowed to carry the $60,000 in cash for the purchase. Both Guinle and the Karnos had to run the gauntlet of the New Orleans mafia during that period headed by mob boss Carlos Marcello. The Famous Door was eventually sold to the Wehner family in August 1992 and run by John Wehner. They invested money in a new stage and sound system. The list of 261 musicians originally displayed has gone, but over the years Louis Prima, Al Hirt, Bobby Darin, Elvis Presley and Ringo Starr have all made an appearance, along with a certain thirteen-year-old piano prodigy. The son of a Louisiana Supreme Court justice and a New Orleans district attorney might have got into trouble for appearing in licensed premises at that tender age, but Harry Connick Jr. survived the experience.

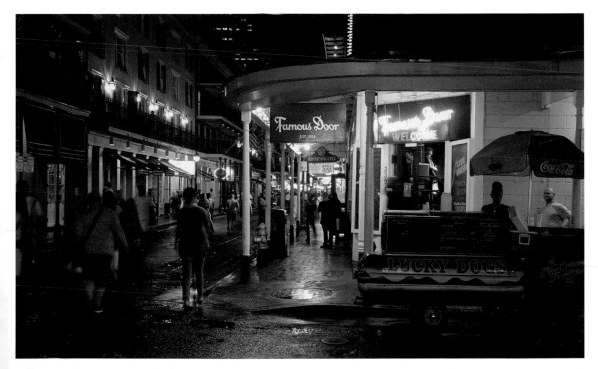

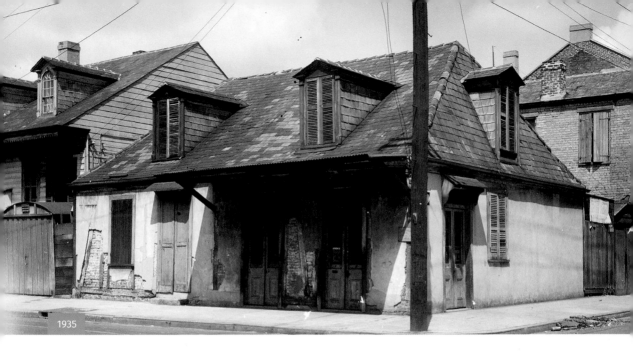

1935

LAFITTE'S BLACKSMITH SHOP

Claimed to be the oldest barroom in America

ABOVE: The building on the corner of Bourbon Street and St. Philip Street in the Vieux Carré was built by Nicolas Touze between 1722 and 1732. The modest French Colonial building had a slate roof that helped it survive two city fires at the start of the nineteenth century. Though no historical city papers remain to confirm the fact, the blacksmith's shop was thought to have been used by the Lafitte brothers, Pierre Lafitte having trained and worked as a blacksmith. Jean and Pierre Lafitte ran a sophisticated smuggling business through New Orleans with a base on

an island in Barataria Bay, Louisiana. It is unlikely that they would have wanted to meet wealthy Creole trading partners to show off goods or slaves in their homes on Royal Street, so the blacksmith's shop was a convenient front. By the time of this photograph it had fallen into disrepair. The Historic American Building Survey described it as being in "...rather bad condition, having been neglected for a number of years. Some of the structural timbers are termite-infested and the stucco has fallen off the walls in many places."

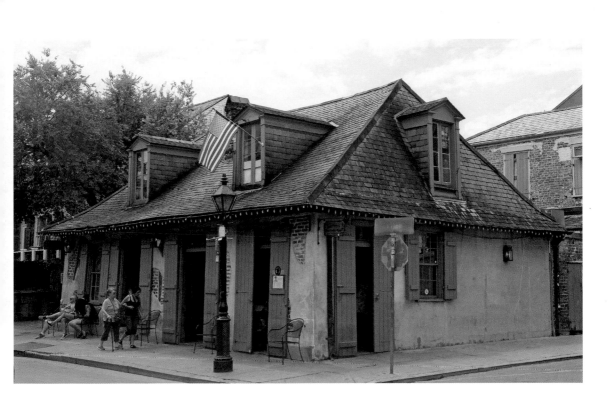

ABOVE: The association between the abandoned blacksmith's shop and the Lafitte name was cemented by Roger Caplinger in the mid-1940s when he opened up the building at 941 Bourbon as Café Lafitte. Despite its distance from the hub of Bourbon Street at Canal Street, it became a popular nighttime haunt and a meeting point for the gay community in New Orleans. Playwrights Noël Coward and Tennessee Williams were among the bohemian clientele the café attracted. Caplinger, who never owned the building, moved out when it was sold in 1953 and set up Café Lafitte In Exile further down the block, which claims to be the oldest gay bar in the United States. The original Café Lafitte also has a claim to the title oldest bar in the country, or, more accurately, oldest building to host a bar. It became a National Historic Landmark in 1970 and is one of the many stops on "haunted New Orleans" tours, placed as it is, conveniently close to LaLaurie Mansion.

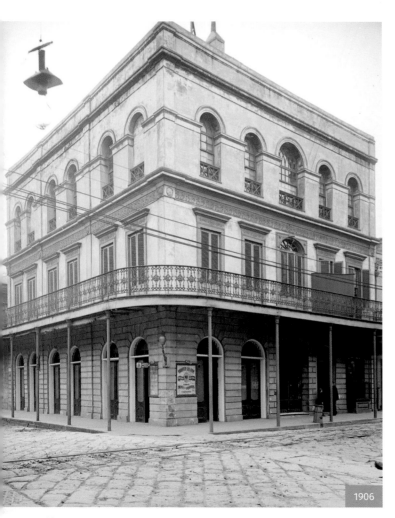

1906

LaLAURIE MANSION

Events at the LaLaurie mansion once set the citizens of New Orleans into a raging mob

LEFT: This photo reveals none of the gruesome history of one of the most haunted houses in America. In 1832 Dr. Louis LaLaurie and his wife Delphine, wealthy Creole socialites who entertained on a grand scale, moved to their splendid quarters at 1140 Royal Street. Rumors of cruelty to slaves became horrifically real on April 10, 1834. On that night a fire broke out in the LaLaurie home, and when the volunteer firemen came to the scene, they discovered dozens of slaves chained to the wall in a secret attic. Some were in cages. Horrible mutilations had been perpetrated, and some slaves cried out, begging to be put out of their misery.

RIGHT: The LaLauries had already fled and were never found. However, a tombstone bearing Delphine's name was discovered nearby in St. Louis Cemetery No. 1, indicating that she died in 1842. The LaLaurie house has had many incarnations before being returned to its purpose as a residence. It was a saloon and a girl's school, a music conservatory, an apartment building, and a furniture store. Throughout its history, the LaLaurie mansion has brought grief to those who own it, and the reports of ghostly activity persist. Several people tell of seeing the ghost of a young slave girl jump to her death from the balcony outside of Delphine LaLaurie's room.

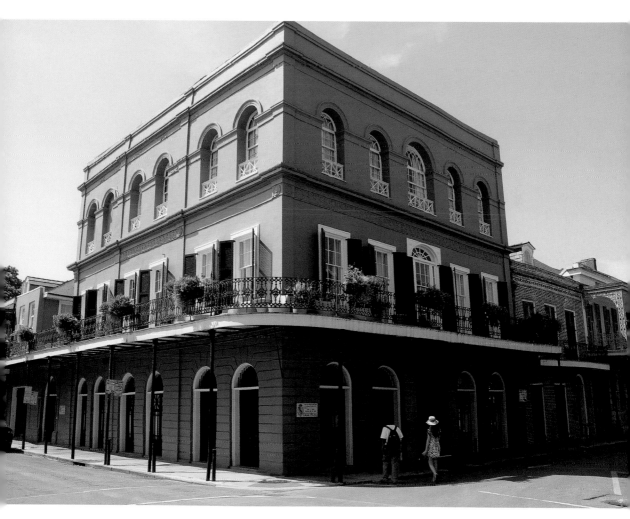

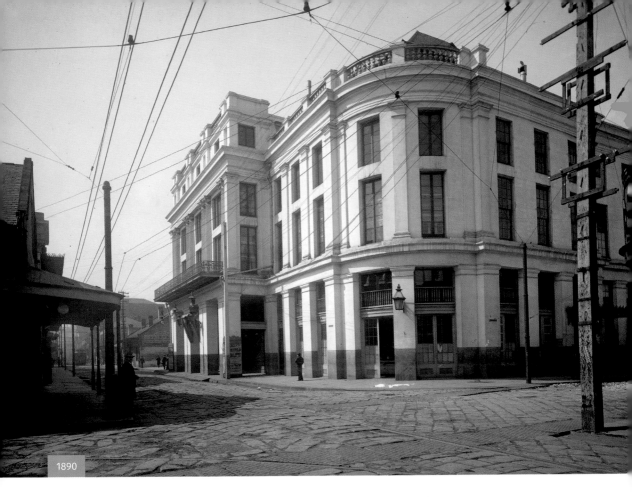

1890

FRENCH OPERA HOUSE / FOUR POINTS BY SHERATON HOTEL

Where French-speaking Creoles enjoyed the grandest of art forms

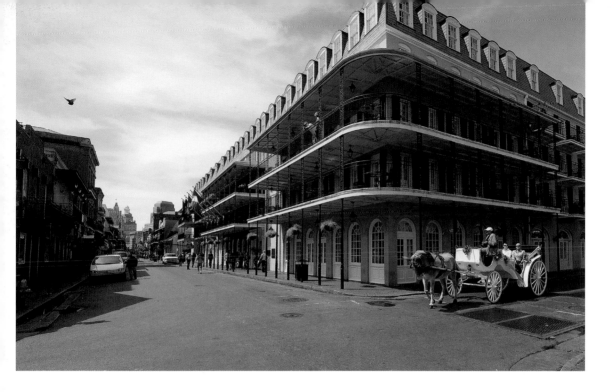

LEFT: The beautiful French Opera House was opened on December 1, 1859, on the corner of Bourbon and Toulouse streets. It was designed and built by architects James Gallier Jr. and Richard Esterbrook to seat 2,800 patrons, and was by all accounts a beautiful structure with excellent acoustics. Considering the total cost was $118,500 and that it was built in less than a year, the French Opera House was quite an achievement. It was especially designed for the presentation of grand opera and was perfectly suited for that purpose, though it ran for just two seasons before the Civil War put a temporary halt to the artistic program.

ABOVE: The French Opera House was destroyed by fire in 1919 and never rebuilt. The building now located on the site is the Four Points by Sheraton Hotel. The hotel acknowledges its opera roots with the Café Opera and the Puccini Bar. With the loss of the French Opera House, New Orleans not only lost its opera venue but also the traditional venue for Mardi Gras balls, debutante balls, and concerts. The New Orleans Opera Company has found a new home in the recently refurbished Mahalia Jackson Theater for the Performing Arts. There are now other venues for Mardi Gras balls, concerts, and benefits.

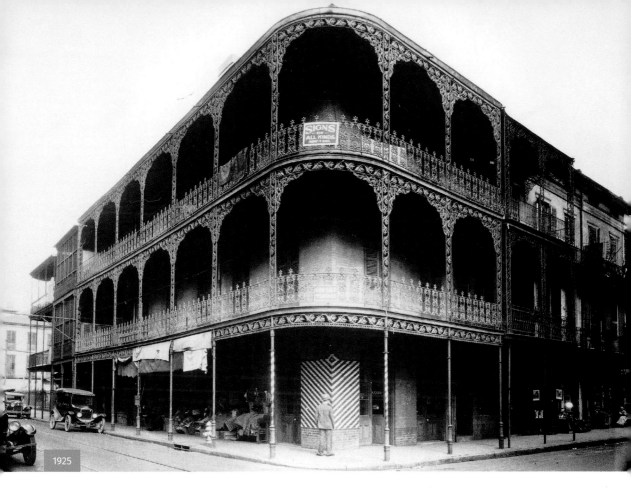

1925

LaBRANCHE BUILDINGS
Some of the finest cast-iron galleries in New Orleans were an afterthought

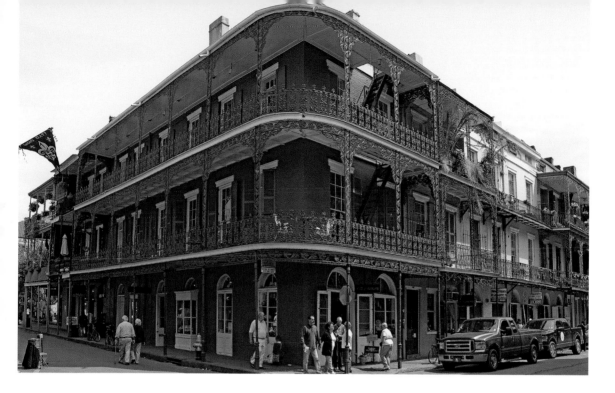

LEFT: This photo shows only part of the complex of eleven Greek Revival town houses built between 1835 and 1840 covering almost the entire block bounded by St. Peter Street, Exchange Alley, Pirate's Alley, and Royal Street. The cast-iron lace gallery was an afterthought, added decades later. The whole complex is referred to as the LaBranche Buildings. Originally on this site was the residence of François Fleurlau, and part of the colonial prison yard. When Jean-Baptiste LaBranche purchased the property in 1835, there were several Creole cottages on the land, which made way for the new development.

ABOVE: Today this gallery of the LaBranche Buildings at Royal and St. Peter streets is one of the most photographed galleries in New Orleans. It's interesting to note that a gallery differs from a balcony in that a gallery has supports that go all the way to the ground, while a balcony does not. The combination of the lacy cast-iron railings of the gallery on the face of simple Greek Revival buildings is a remarkably beautiful sight. This is a fine example of how the Spanish left their mark on New Orleans during their control of the city. These buildings are in use today as restaurant, commercial, and residential spaces.

ROYAL STREET

New Orleans's prosperity was reflected in Royal Street, the street of banks

BELOW: During the 1850s, New Orleans was the richest city in America and Royal Street was the street of banks. A walk down Royal Street is a walk through history. This storied street includes the residences of Francois Seignouret, a master carpenter who designed and manufactured furniture in his home. These "Seignourets" are prized by discriminating antique collectors. Prudent Mallard, another fine furniture maker, also lived on Royal Street. The Merieult House, now part of the Historic New Orleans Collection, was built in the 1790s, and is one of the oldest structures in the city.

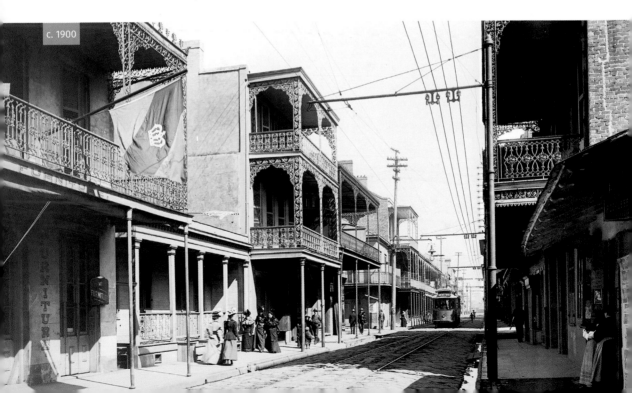
c. 1900

BELOW: Today Royal Street runs from the edge of the French Quarter at Canal Street, goes through the French Quarter, and continues on through the historic streets of New Orleans. A stroll down Royal Street is a must for anyone interested in architecture. There are prime examples of early Creole architecture, Greek Revival houses with heavy wood cornices, and typical row houses of the 1830s. Many cast-iron balconies and galleries on the street are bedecked with hanging flowers and ferns. Toward Esplanade Avenue, Royal Street becomes residential and changes character as well. This more quiet part of Royal Street is in sharp contrast to the first few blocks that are filled with music, shoppers, and diners.

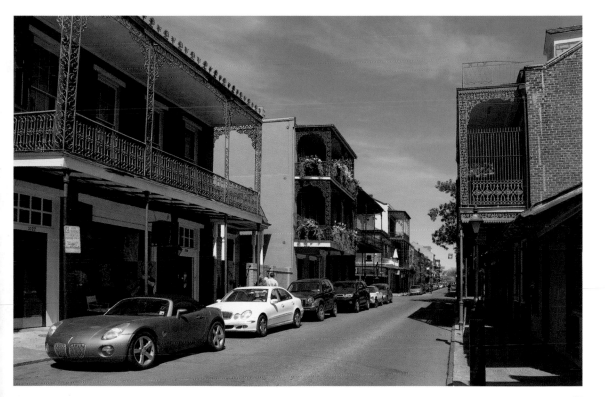

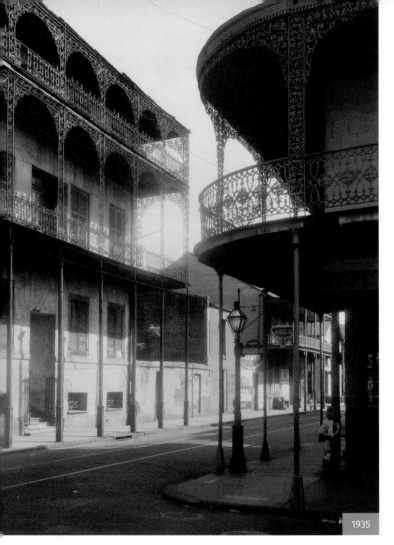

1935

GARDETTE-LE PRETRE HOUSE

The building is also known as the "Sultan's Palace"

LEFT: In 1836 Joseph Gardette contracted with Frederic Roy to build this home on Dauphine Street. Gardette sold the home to Jean-Baptiste Le Pretre in 1839. It was Le Pretre who added the cast-iron galleries. During the Civil War in 1861, part of the captured flagstaff of Fort Sumter, sent to New Orleans by Confederate general P. G. T. Beauregard, was presented to the Orleans Guards in this house. However, the real draw of this house doesn't have anything to do with the Civil War. It relates to a legend about one of New Orleans's most famous ghosts. As the story goes, a mysterious Middle Easterner rented the mansion in the 1870s. The man and his harem were all found murdered, the result of a request by the angry sultan to whom the harem belonged. Since that time the home has been more popularly known as the "Sultan's Palace" or the "House of the Turk."

RIGHT: Today the Sultan's Palace continues to be on the map of ghost hunters everywhere. It's now a private residence with the same graceful lacy galleries it sported in the nineteenth century. The house is on Dauphine Street in a quiet residential part of the French Quarter just a few blocks—yet worlds away—from the wild party atmosphere of Bourbon Street.

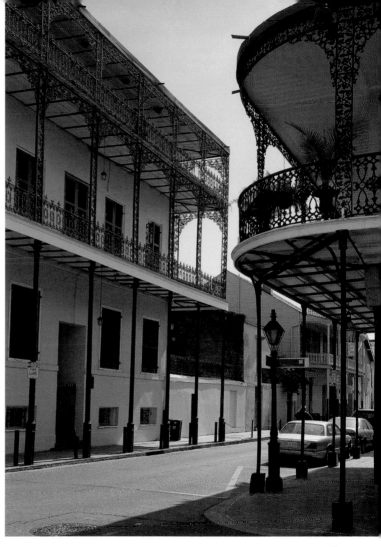

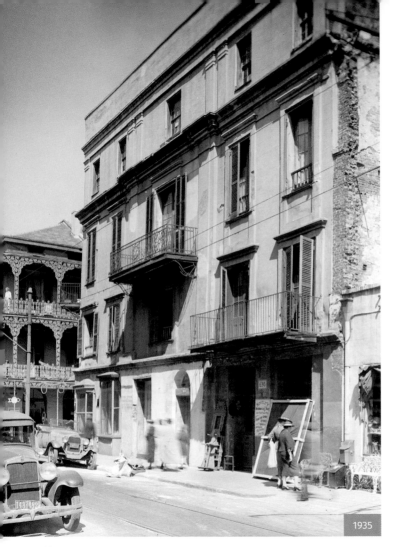

1935

FIRST "SKYSCRAPER"
New Orleans's bid to rival Chicago barely got off the ground

LEFT: The building in this photo is on the 600 block of Royal Street in the French Quarter, and is known as the first skyscraper built in New Orleans. At the time it was built, in the early nineteenth century, it was the tallest building in the French Quarter. Of course the term "skyscraper" hardly applies to this four-story building, and the word was not used in the nineteenth century. But when it was constructed, this building towered over every other building in the French Quarter. Its ironic title as the first skyscraper in New Orleans came in the twentieth century, when construction technology advanced enough to build a real skyscraper on New Orleans soil.

RIGHT: The building is still in use, but is certainly not considered tall. It was trumped as the tallest building in New Orleans by the construction of the St. Christopher Hotel in 1893. Today the skyline of New Orleans reveals several true skyscrapers, the tallest of which is the fifty-one-story One Shell Square on the corner of St. Charles Avenue and Poydras Street. Height restrictions are strictly imposed in the Vieux Carré to maintain the historic nature of the area, making a view from a French Quarter street toward Canal Street a beautiful sight. The old buildings of the French Quarter juxtaposed against the tall, modern buildings of the Central Business District make a compelling contrast.

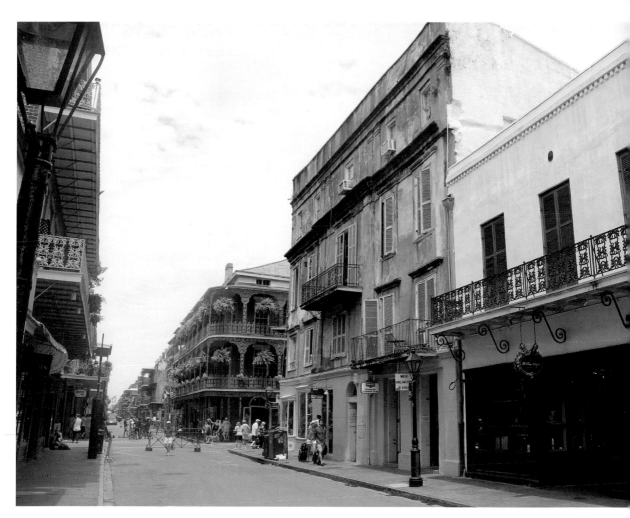

ESPLANADE AVENUE

A grand old residential district on the route out to City Park

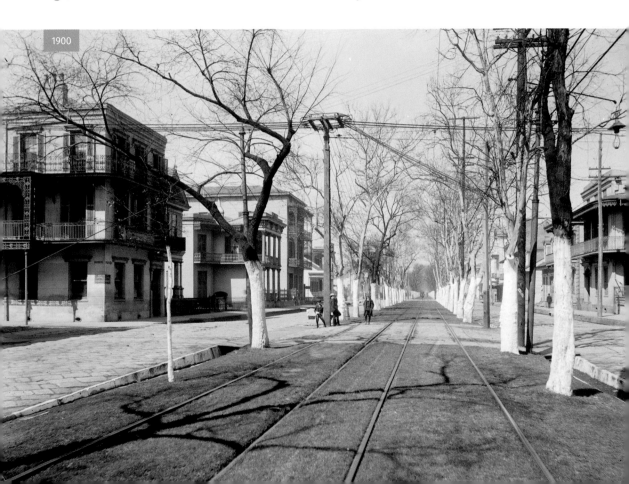

1900

LEFT: In the early days of New Orleans the downriver end of the Vieux Carré was often fortified against possible enemies that might invade the city by sailing up the Mississippi. From 1742 to 1792, the site that would later become the head of Esplanade Avenue was part of the Marigny plantation. It became property of the city in 1810 and was subdivided into lots. Artisans and tradesmen built homes on the lots. When the city became more affluent in 1835, Esplanade Avenue was paved, and streetlamps and banquettes (sidewalks) were installed. By the time this photo was taken, larger, more lavish homes had been built.

BELOW: Esplanade Avenue is now the border between the Vieux Carré and the neighborhood of Faubourg Marigny. The street has a wide variety of architectural styles. Esplanade Avenue is still largely residential and runs out to the entrance of City Park and the New Orleans Museum of Art. The avenue passes through the Esplanade Ridge neighborhood of New Orleans, so named because it is located on a higher strip of land that marks the old Native American portage connecting Bayou St. John with the river. This neighborhood suffered from the 1960s construction of Interstate 10, which split the neighborhood.

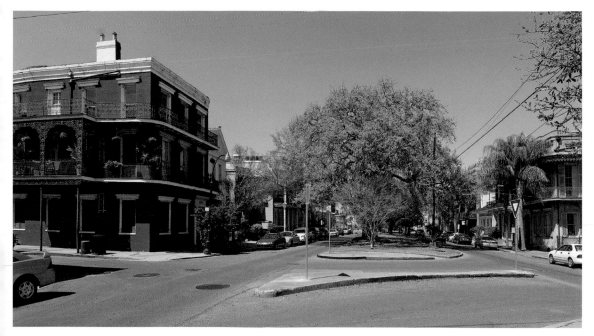

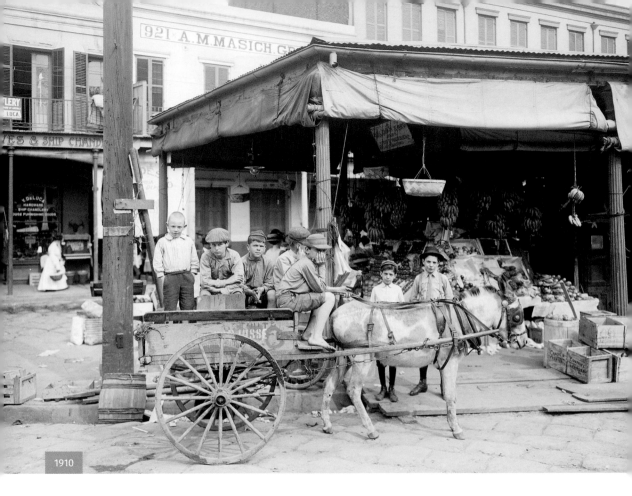

1910

FRENCH MARKET

Nowhere was the city's diverse background more apparent than in the French Market

46

LEFT: Everyone in the family came to the French Market in 1910. If the Vieux Carré is the heart of New Orleans, then the French Market is the heart of the Vieux Carré. The market served as a grocery store and meeting place to swap recipes and the news of the day. New Orleans's location on the river made it easy for merchants and farmers to get their products to market. Free people of color sold coffee, the French sold meat, the Spanish and Italians sold fruit, and Germans sold vegetables. There were Moors, with their strings of beads from the Holy Land, Jews, Chinese, Irish, and Creoles—all met at the French Market.

ABOVE: As shopping for fresh produce dwindled in the twentieth century, so the market contracted back to the main buildings, leaving this far end redundant, eventually being replaced by a traffic median. The market buildings were completely renovated recently and a flea market has been added, making the French Market several blocks long. A statue of Joan of Arc, patron of New Orleans, has been placed in front of the market. To add interest, through the year there are a series of events including the Creole Tomato Festival, Boo Carré Halloween and Harvest Festival, and a Christmas tree lighting ceremony.

FRENCH MARKET

Historians believe there was a market on this site before there was even a settlement

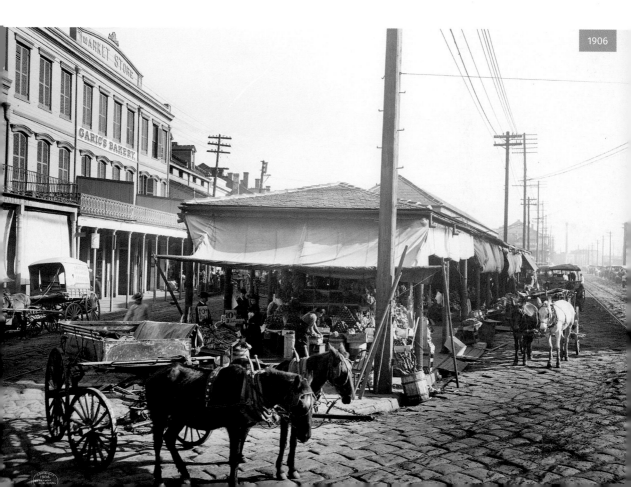

1906

LEFT: The French Market has existed on this site since 1791, and it has changed and expanded over time. These photos show the bustle surrounding the market that still occurs today. In the late nineteenth century, many of the vendors were Sicilian, immigrants originally recruited by plantation agents in the 1880s and 1890s as migrant farmworkers. This market predates New Orleans, as it was used as a trading post by the Louisiana Choctaws living in the area before the eighteenth century. The French Market is where New Orleanians have come to buy fresh food for over 200 years and is America's oldest public market.

BELOW: The French Market on Decatur Street has survived several changes of nationality, from when Louisiana reverted from French to Spanish rule, to when it went back to French control, and to its sale to the United States in 1803. The French Market district is made up of six blocks and consists of the Butcher's Market, the Cuisine Market (occupying the old Seafood Market), the Bazaar Market, the Red Stores, the Vegetable Market, and the Farmers' Market Sheds—only one of which is used by farmers to sell produce direct. The golden statue of Joan of Arc was donated to New Orleans by the people of France in 1958.

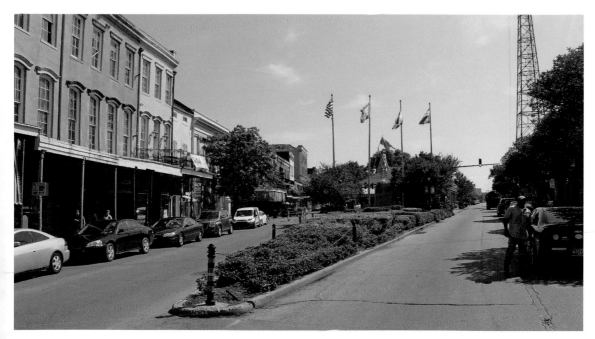

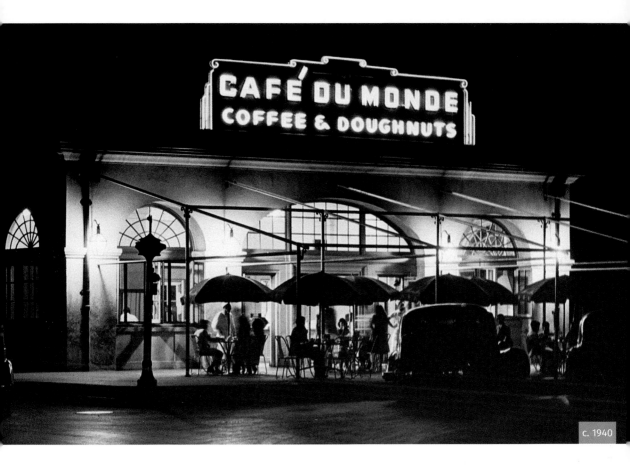

c. 1940

CAFÉ DU MONDE
Serving coffee and beignets since 1862

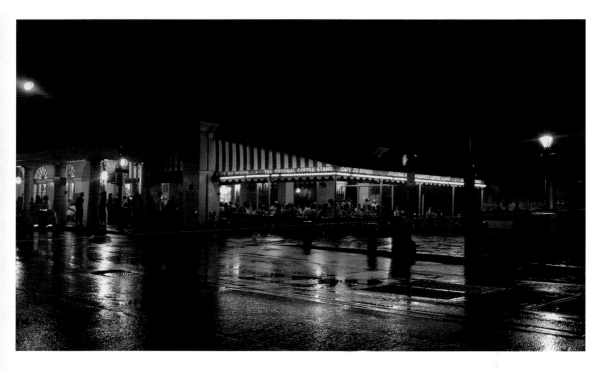

LEFT: This photograph shows Café du Monde in the heat of a summer night around 1940. The café is the original French Market coffee stand, established in 1862 at one end of the Halle des Boucheries, or Butcher's Market, and it is the building's oldest tenant. The original market was destroyed in a hurricane in 1812, and the building that exists today was constructed the following year. Around the time of the Civil War and the federal occupation, chicory began to be added to coffee served at the café, a tradition that has lasted 150 years.

ABOVE: Café du Monde has been owned and operated by the Fernandez family since 1942. It is still a favorite for natives and visitors alike, who can enjoy strong chicory coffee and beignets. Over time, the café has expanded outward with tables overlooking Jackson Square and Decatur Street. Generations of New Orleans children and adults have long enjoyed sugary beignets at any time of the day. It is open 24/7 except on Christmas Day and when the occasional hurricane strikes.

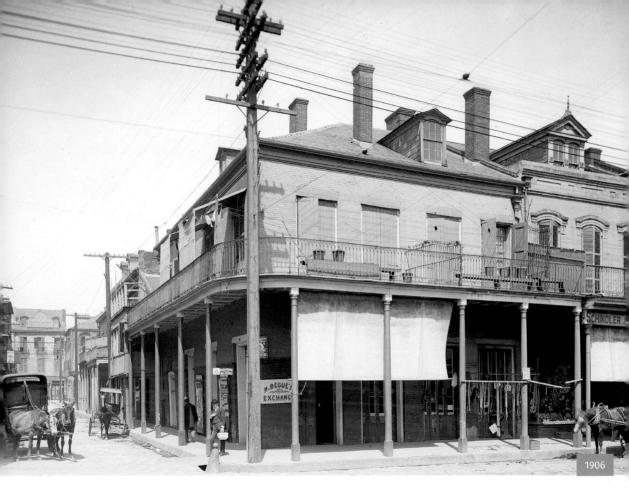

1906

MADAME BEGUE'S / TUJAGUE'S
The restaurant that became a New Orleans institution by serving one meal a day

LEFT: Since the 1860s, Madame Begue fed the people of the French Quarter—especially those out to shop at the French Market—from her restaurant on the corner of Madison and Decatur. The original name of the restaurant was Dutrey's. When her husband died, she married Hippolyte Begue and changed the name of the restaurant to Begue's. She served only one meal, a large breakfast at 11:00 a.m. That was a perfect time for dockworkers who had been on the job since early morning. In 1884 these elaborate late breakfasts were discovered by tourists who came to New Orleans for the World's Fair.

ABOVE: Madame Begue died in 1902 and the restaurant was taken over by her daughter and son-in-law. This corner is now occupied by Tujague's, a restaurant with its own storied history. Guillaume Tujague was a butcher in the French Market before he established Tujague's Restaurant in 1856, a few doors down from Madame Begue's. Eventually the owners of Tujague's and Begue's joined forces and hung up the Tujague sign on the Begue corner in 1914. However, Madame Begue has not been forgotten. The Royal Sonesta Hotel has a restaurant named Begue's that serves a champagne brunch in her honor.

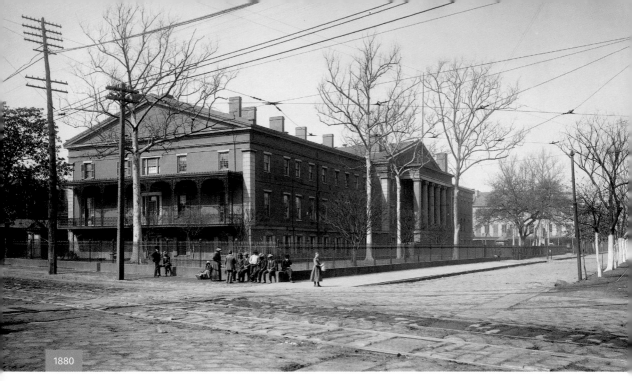

1880

U.S. MINT
An important resource for the Confederacy that was lost in the 1862 seizure

ABOVE: This photo shows the neoclassical structure built in 1835 by the U.S. government to mint coins. At its peak in the 1850s, the mint produced about $5 million in gold and silver coins per year. When Louisiana seceded from the Union before the Civil War, the mint was seized and then turned over to the Confederates, who used it to mint their currency and to house troops. The U.S. government regained control of the mint after New Orleans was seized in 1862. The

new governor of the city, Major General Benjamin Butler, provoked strong criticism by executing William B. Mumford, who had torn down a flag that victorious commander David G. Farragut had placed on the U.S. Mint. It was used once again to mint U.S. currency, thus took its place in history as the only mint to produce currency for both sides during the conflict.

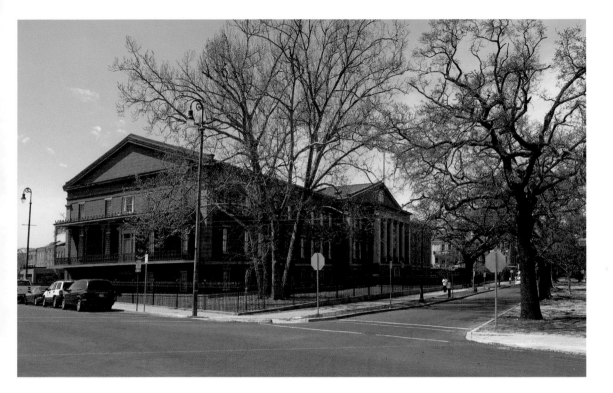

ABOVE: The building ceased operations as a mint in 1909. Since that time it has been used for various purposes by the federal government, including a prison for bootleggers during Prohibition. It was turned over to the State of Louisiana in 1966 for use as a museum. The New Orleans Mint now features a world-famous exhibit on jazz. The third-floor auditorium and wide, covered balconies look out over the historic French Market and French Quarter, and the lighted cityscape of the Central Business District. Many festivals, including the French Quarter Festival and the Creole Tomato Festival, are held on the grounds of this grand old building. It is on the National Register of Historic Places and is one of the many museums in the French Quarter under the umbrella of the Louisiana State Museum system.

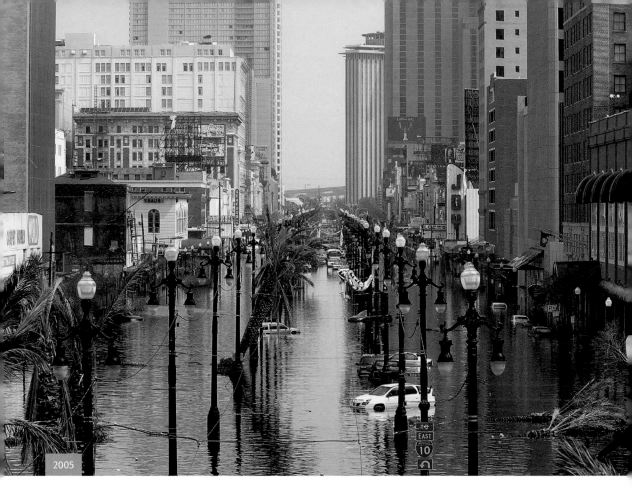

2005

CANAL STREET
The central artery of the city marking the boundary between districts

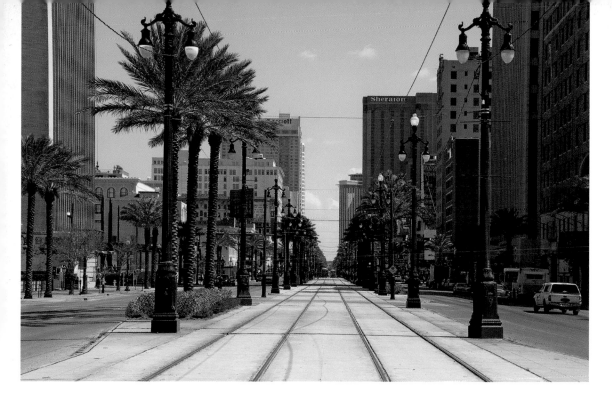

LEFT: On August 29, 2005, the levees broke after the eye of Hurricane Katrina passed near New Orleans. Over 80 percent of the city flooded, causing perhaps the worst natural disaster in American history. Only the oldest part of the city and, ironically, areas closest to the river, escaped the devastation. This photo shows the flooding on Canal Street from Claiborne Avenue looking toward the Mississippi River shortly after the levee failure. The floodwaters remained for several weeks, causing the city to be closed down. The higher ground closer to the Mississippi River, including the French Quarter, remained dry.

ABOVE: Some of New Orleans is below sea level, but the oldest parts of the city and those parts nearest the river are above. Although New Orleans still has more recovery to complete, the downtown, uptown, and French Quarter sections of the city have been restored to their former glory. Some areas are still being redeveloped and New Orleans has conducted an extensive program to plan for the future. A number of factors have helped to accelerate recovery, including the introduction of a $14.5 billion storm damage risk reduction system with new and improved levees, floodwalls, floodgates, and pump stations.

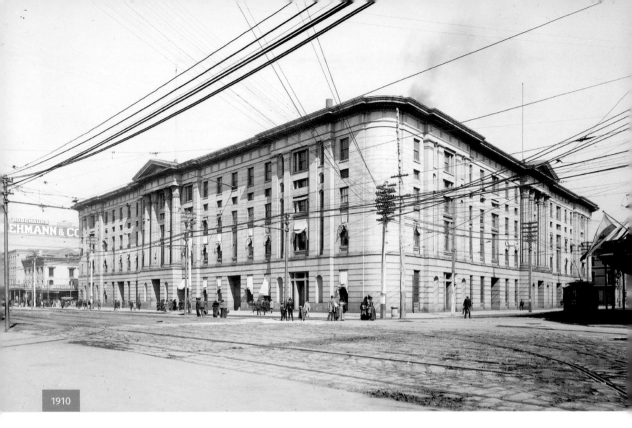

1910

CUSTOM HOUSE / AUDUBON INSECTARIUM
The size of the Custom House was a reflection of New Orleans's importance as a port

ABOVE: New Orleans's location on the Mississippi River made the city one of the major ports of the United States, and a large customs house was needed. The U.S. Custom House on Canal Street was begun in 1848 but not fully completed until after the Civil War. This building, which also served as a post office and housed other federal offices, was one of the largest buildings in New Orleans at the time it was built. It takes up an entire city block and is basically a Greek Revival design with Egyptian Revival accents.

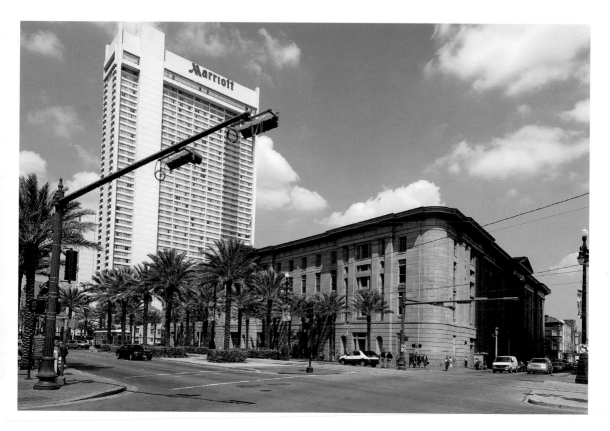

ABOVE: The grand Marble Hall in the center of the building is one of the finest Greek Revival interiors in the United States. The building was used as an office by Major General Benjamin "Spoons" Butler, the officer in charge of New Orleans during Union occupation, and also served as a prison for Confederate soldiers. The U.S. Custom House is in use today for a vastly different purpose. It is operated by the Audubon Institute as the Audubon Insectarium. It is the largest museum in North America devoted to insects and their relatives, and houses thousands of live and preserved specimens. Since its opening in 2005, it has become a favorite place for families to visit.

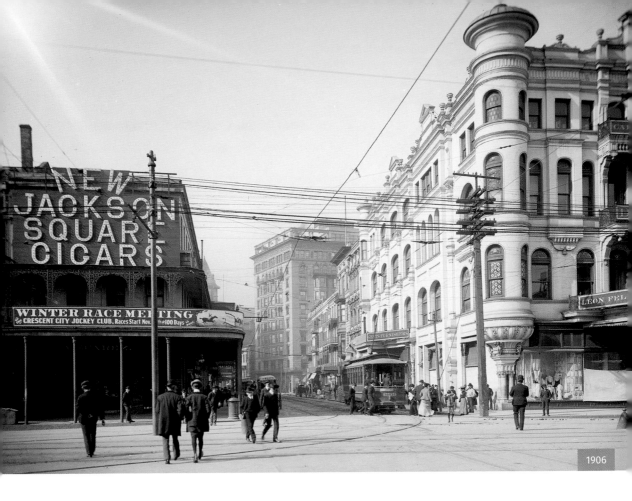

1906

CARONDELET STREET AT CANAL STREET
Still a thriving area of commerce in the American Sector

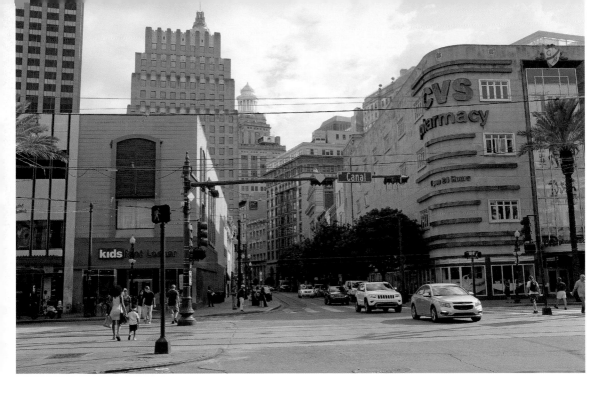

LEFT: This photo shows the American Sector from Canal Street. Carondelet Street was a main commercial area at the turn of the century and remains so today. The streetcar is the St. Charles Avenue Streetcar that runs uptown from Canal Street. The width of Canal Street, compared with intersecting streets, is clearly seen here and is the result of the attempt by the Creoles to keep the Americans at a distance after the Louisiana Purchase in 1803. The architecture on the American side of the city is in sharp contrast to the other side of Canal Street, where the Creoles lived and worked together in the Vieux Carre.

ABOVE: Canal Street remains one of the widest roadways in America that is not designated as an avenue or boulevard. Carondelet Street is a major part of the Central Business District, with many office buildings lining the sidewalks. Banks, restaurants, and hotels have been added to the landscape of Carondelet Street and the Central Business District, making this area busy not only during business hours but also at night. Although the buildings have been modernized, one thing remains the same: the old green St. Charles Streetcar still runs down Carondelet Street to Canal Street and then goes back uptown on St. Charles Avenue.

1910

MAISON BLANCHE / RITZ-CARLTON

The onetime home of Mr. Bingle

LEFT: Canal Street was the main shopping street in New Orleans for generations. The building at 921 Canal Street was the home of the famed New Orleans department store Maison Blanche. The company was started by German émigré Isidore Newman in 1897, and its success helped spawn a chain of Maison Blanche stores. The building shown on the left was erected between 1908 and 1909 and also housed commercial offices, as well as dentists' and doctors' offices. The department stores along Canal Street had large windows decorated with the latest fashions, and at Christmastime the front of this building was graced by the snowman Mr. Bingle, a favorite among New Orleanians.

RIGHT: The Maison Blanche Building is now part of the New Orleans Ritz-Carlton Hotel. Most of the department stores along Canal Street have been turned over to hotels, and as the tourism industry has grown in New Orleans, the shopping on the street has declined. The Ritz-Carlton suffered considerable damage in the aftermath of Hurricane Katrina and the flooding necessitated a $106 million refit; the hotel reopened for business in December 2006. Mr. Bingle has found a new home in City Park at the annual Celebration in the Oaks light display.

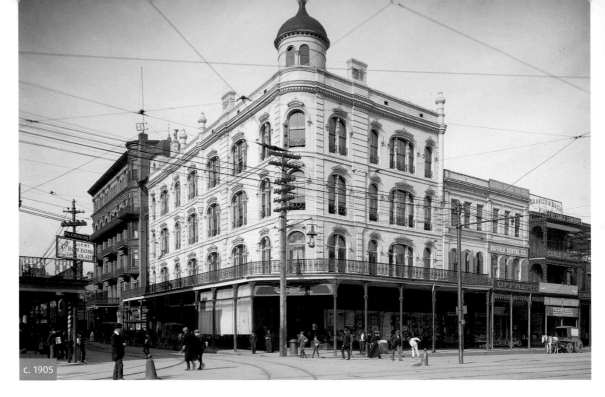

c. 1905

CHESS, CHECKERS, AND WHIST CLUB / WALGREENS
The corner of Canal and Baronne has been home to the Art Deco Walgreens building since 1938

ABOVE: The Chess, Checkers, and Whist Club was a social club with lofty ambitions. Founded in 1880, it was formally dedicated in 1882 to "promote the knowledge and encourage the development of the scientific games of Chess, Checkers, and Whist" along with the "cultivation of literature." The club had many different homes as membership grew rapidly in the early 1880s, first in Gravier Street, then Common Street and finally at the corner of Canal Street and Baronne. The original building on the site, along with a lot of the club's memorabilia and library, was lost in a fire of 1890 but a splendid new replacement soon appeared on the corner. The club leased it for an original sum of $5,000 per annum. For the next thirty years the club held its tournaments and amusements here.

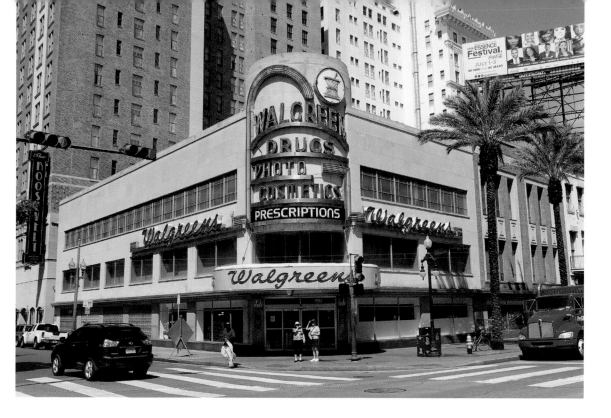

ABOVE: By the early twentieth century Canal Street was becoming too congested for Victorian-style gentlemanly leisure. More significantly, the owner of the building renewed the club's lease at $10,000 per year, double the original rent, and when it rose again to $12,500 the committee decided to move out and buy their own home. The Chess, Checkers, and Whist Club continued on Bourbon Street for another fifteen years, but more modern diversions and dwindling membership brought it to a close in 1935. The old clubhouse at Canal and Baronne took on new tenants and came to be known as the Beer Building. Investors contemplated the busy corner location for commercial uses, particularly with the popular Maison Blanche department store across Canal Street. Missing its signature corner cupola in its latter years, the old clubhouse was cleared in 1937 and replaced the next year by the Art Deco–style Walgreens, still in operation today as a flagship location of the pharmacy chain.

SOUTHERN RAILWAY STATION
Located at the cultural crossroads of New Orleans, right next to Storyville

1910

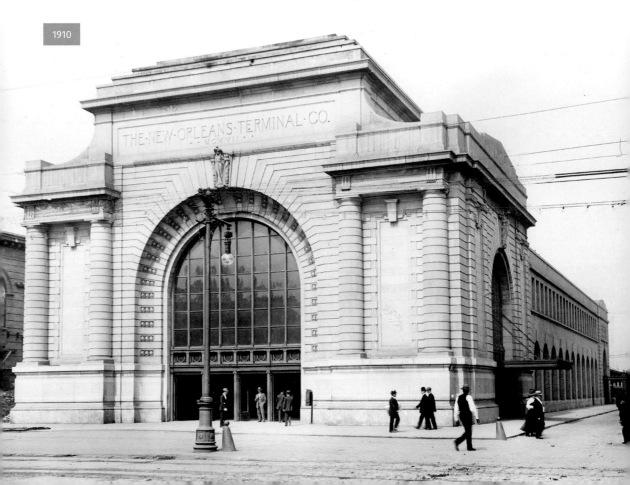

LEFT: The Southern Railway System Passenger Station was constructed in 1908 and demolished in 1956. When the station was built on the corner of Basin and Canal streets, it was at the cultural crossroads of New Orleans. The turning point for the old Basin Canal built by the Spanish in 1786 was nearby on Carondelet Street. The canal provided a link between the city and Lake Pontchartrain to the north. The railroad station was the terminus of the railroad where locals and visitors came and went. The area around the station was filled with lumberyards and mills. It was also adjacent to the Storyville district, home to legalized prostitution, dance halls, and great music venues.

BELOW: Storyville is gone, and so is the original railroad station. Storyville was closed down by the U.S. military in the 1920s, and the dance halls and jazz joints that filled the area are also gone. The canal has been filled in and paved over with streets. The only clue that this is the same location is the building on the left, the former Krauss Department Store and now 1201 Canal condominiums. One of its windows can be seen far left in the 1910 photo. The area around Basin Street, known as Treme, is still home to many of New Orleans's fine musicians.

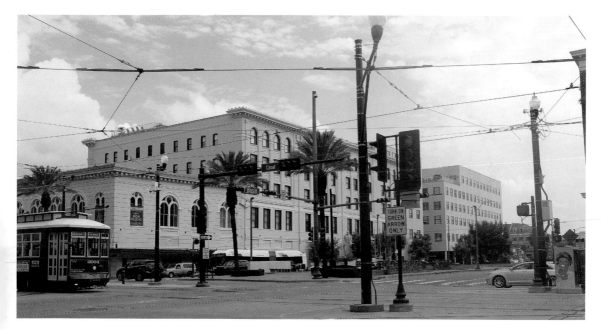

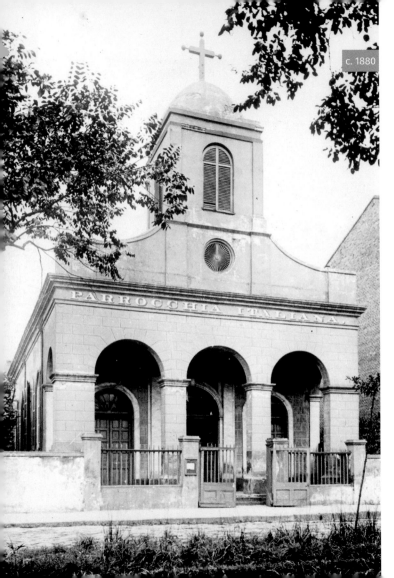

MORTUARY CHAPEL / ST. JUDE'S

No longer caring for the souls of yellow fever victims

LEFT: The little chapel is the oldest existing church in New Orleans and is built on the edge of the Vieux Carré. It was called the Mortuary Chapel because bodies piled up to be buried during the deadly outbreaks of yellow fever. They would be brought here, outside of the city, until burial could take place. In the late nineteenth century it became a church for the city's Italian immigrants. This chapel is also the International Shrine to Saint Jude, the saint of the impossible. A plaque to victims of yellow fever, dated 1826, stands next to the chapel. In the rear of the chapel stands the only extant statue of Saint Expedite. The story is that the statue arrived in a box marked "expedite," so the nuns gave the statue that name.

RIGHT: St. Jude's is no longer the Mortuary Chapel, as the threat of yellow fever has long since passed. Now known as Our Lady of Guadalupe, it remains the International Shrine of Saint Jude. It is the official chapel of the New Orleans Police and Fire departments, which hold a celebratory mass there every year. The chapel sits on the edge of Treme, a neighborhood that is home to many fine New Orleans musicians. During the 1980s, many of the best New Orleans musicians, including Aaron Neville, Alan Toussaint, and Lady B. J., would sing at midnight mass here. A recording of one of those masses is highly prized among fans of New Orleans music.

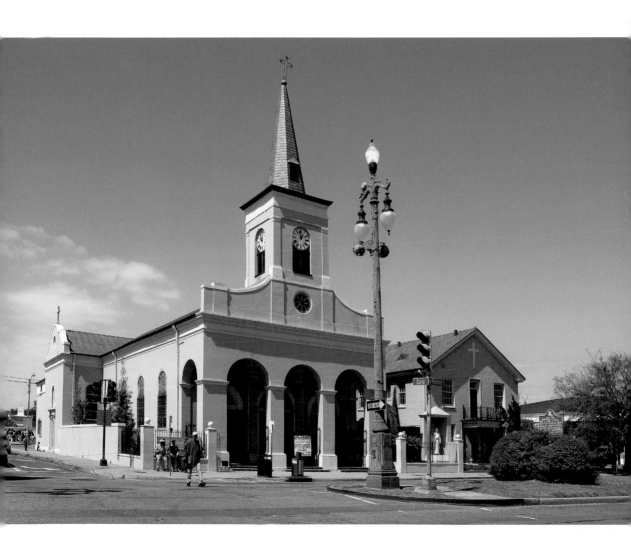

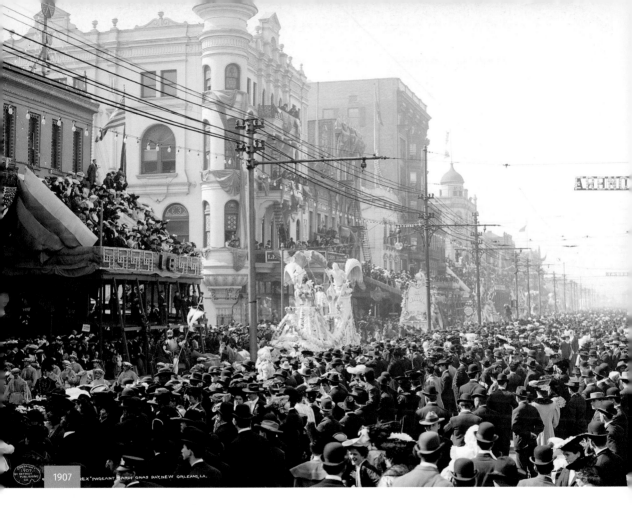

1907 REX "PAGEANT" MARDI GRAS DAY, NEW ORLEANS, LA.

CANAL FROM CARONDELET STREET
New Orleanians have been celebrating Mardi Gras since the 1700s

LEFT: The pageantry that is Mardi Gras is highlighted in this 1907 photo of the Rex Parade working its way along Canal Street. Some of the carnival parades continued across Canal Street and into the French Quarter. However, that practice was stopped in 1972 when floats got too large for the narrow streets. New Orleans has celebrated Mardi Gras since the French first settled here in the early 1700s. Now the entire carnival season, from January 6, the Feast of the Epiphany (or King's Day) until Mardi Gras (Fat Tuesday), the day before Ash Wednesday, is cause for celebration.

ABOVE: Canal Street has been revitalized in recent years with upgrades to the sidewalks and landscaping. The city has also returned the Canal streetcar line to help with traffic and provide a fun, convenient way to travel up and down Canal Street, on the "neutral ground." For about two weeks before Mardi Gras, carnival parades roll down Canal Street. These parades end on Fat Tuesday when Rex, King of the Carnival, and the rival Zulu parade (which started in 1909) fill the streets of New Orleans. The party continues until midnight, when the streets are cleared and things go back to normal.

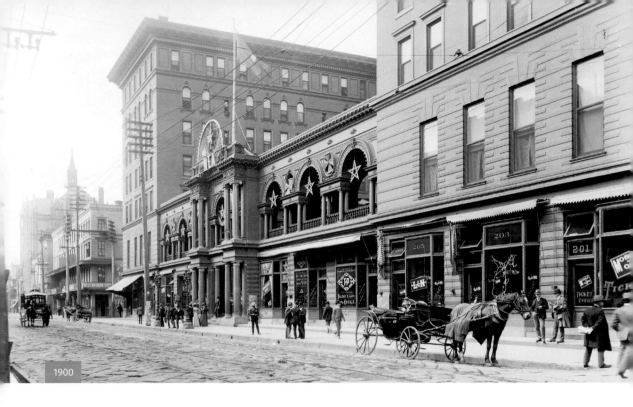

1900

ST. CHARLES HOTEL
A grand rival to the St. Louis Hotel of the Vieux Carré

ABOVE: The St. Charles Hotel is a prime example of the rivalry between the Creoles in the Vieux Carré and the Americans in the American Sector. In 1837 this grand hotel on "the Avenue" was built at a cost of $800,000 to rival the St. Louis Hotel in the Vieux Carré. Prior to the Civil War, much of New Orleans's social life revolved around events in these lavish hotels. Grand balls for Mardi Gras or debutantes were held in the lavish ballrooms of the St. Charles. The original building was destroyed by fire in 1851, and its replacement was erected shortly afterward. It was extensively renovated and expanded in 1878. At that point it had 400 rooms, office space, a restaurant, and a bar.

72

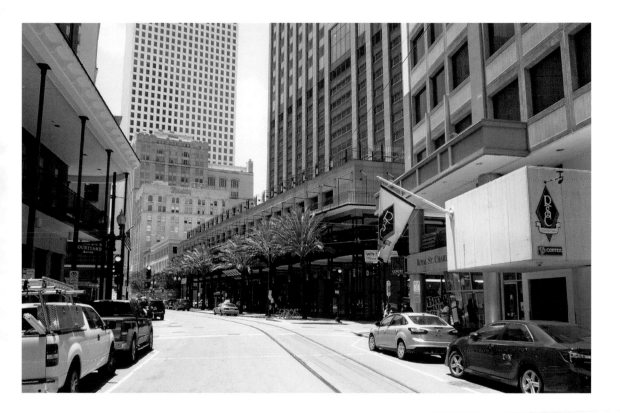

ABOVE: The second St. Charles Hotel burned down in the early 1890s and was rebuilt in 1896. This third hotel was demolished in 1974. Since 1984, one of the tallest office buildings in New Orleans, the Place St. Charles, has stood on the site of the former St. Charles Hotel. The Place St. Charles is a fifty-three-story, 645-foot tall skyscraper in the Central Business District. Its architecture is vastly different to the hotel that formerly stood on this site. The new granite-and-glass structure is softened by the French Quarter–style balconies on the first three floors. It houses a hotel, a shopping mall, offices, and a food court. Although suitable for today's needs and an architecturally pleasing structure in its own right, the Place St. Charles could never replace the St. Charles Hotel and the era it represented.

ST. CHARLES AVENUE
The grand street of the American Sector

BELOW: St. Charles Avenue has long been established as "the Avenue" of the American Sector, as this photo shows. Running uptown from Canal Street, St. Charles Avenue starts in the Central Business District, runs through the American Sector, past the Garden District, universities, and parks, and ends up in Carrolton at a bend in the Mississippi River. This view shows the beginning of St. Charles near its intersection at Canal Street. This part of St. Charles Avenue was largely commercial and was lined with office buildings, banks, and some shops, restaurants, and hotels. St. Charles Avenue widens at Lee Circle and has a large neutral ground in the middle to accommodate the St. Charles Streetcar line. The avenue at this point begins to become more stately, with mansions and large live oak trees on the route.

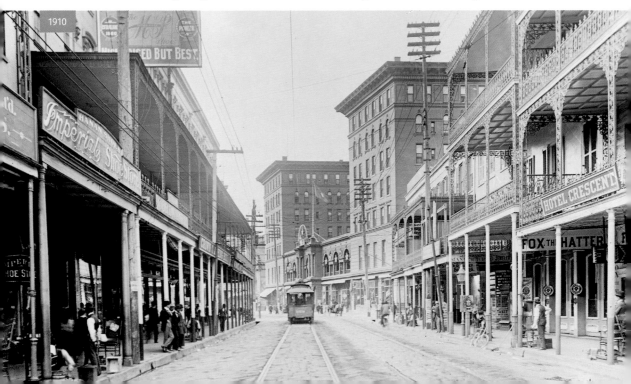

BELOW: St. Charles Avenue continues to be the main avenue on the American side of the city. The St. Charles Avenue Streetcar still runs on tracks in the middle of the street for the entire length of the avenue and provides a scenic ride through uptown New Orleans for a nominal price. St. Charles Avenue is also the main route for Mardi Gras parades in New Orleans. The mansions along the avenue, built in the last century, are still occupied, and Audubon Park, established after the New Orleans World Cotton Centennial in 1884, gets more scenic every day with the live oak trees, palms, and abundance of birds. Tulane and Loyola universities front on St. Charles Avenue, and it is often called the "Avenue of Churches" for the many beautiful churches and cathedrals along the avenue.

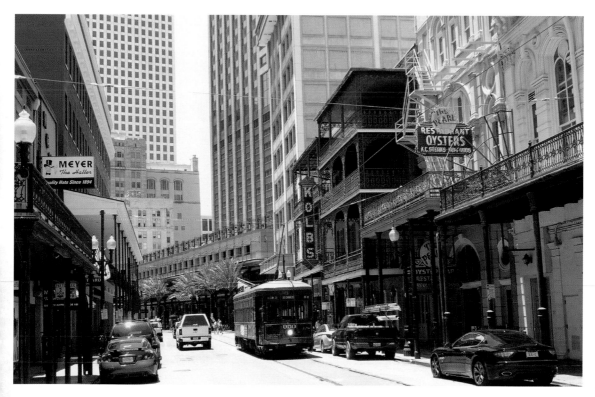

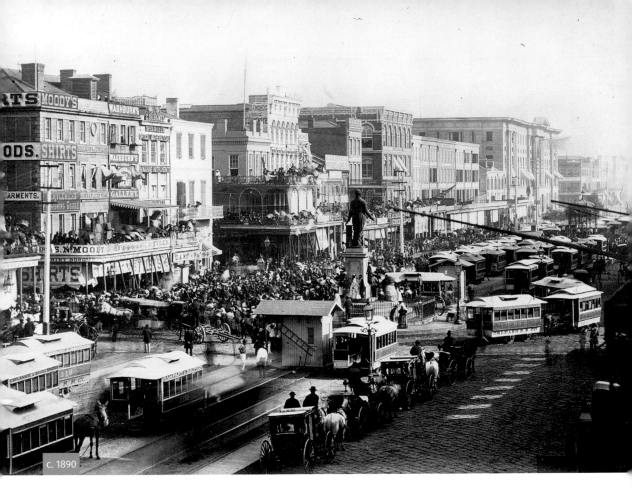

c. 1890

CANAL STREET AT ST. CHARLES AVENUE
The canal, for which the street was named, never arrived

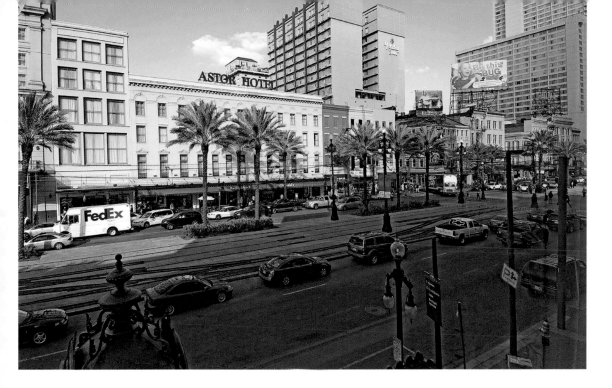

LEFT: Canal Street was so named because it was originally intended that a canal be dug along the street. That never happened, but the name stayed. Canal Street is the border between the Creole section and the American Sector. The city leaders decided to beautify Canal Street in the 1850s, and a circle at the intersection of Canal Street and St. Charles Avenue was created. In 1856 a statue of Henry Clay, a statesman admired by the leaders of the city, was placed in the center of that circle. In this photo the statue looks down Canal Street toward the Mississippi River. Other plans to add more monuments to Canal Street never came about.

ABOVE: Both the circle and the statue are now gone. Streetcars run along the neutral ground and Canal Street has been widened to facilitate the flow of traffic. Clay's statue was moved from its place on Canal Street in 1900. It now watches over the comings and goings in Lafayette Square in the American Sector. The same streetcars that rumbled past the statue on Canal Street still rumble past its new home in Lafayette Square. There is also a major street in uptown New Orleans that bears Clay's name.

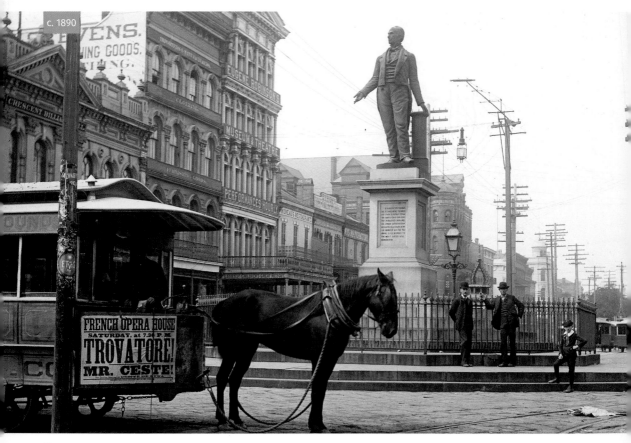

c. 1890

LEFT: The statue of U.S. Senator Henry Clay is shown here in its original location on the corner of Canal Street and St. Charles Avenue. The statue was moved to the center of Lafayette Square in 1900. Lafayette Square is the second-oldest park in New Orleans, dating to 1788. Originally called Place Gravier in 1824, it was renamed for Revolutionary War hero Gilbert du Motier, Marquis de La Fayette, after he visited here. Following the great fire in the Vieux Carré in 1788, Jackson Square became a tent city, and Lafayette Square became the gathering place for local meetings. It was the site of anti-Union demonstrations, mayoral inaugurations, and band concerts in the nineteenth century.

RIGHT: Now firmly in place for over a century, Henry Clay surveys the increasing greenery of Lafayette Square. During the Depression in the 1930s, the Works Progress Administration executed both arts and construction projects here as part of their remit for job creation. The old oaks were damaged in Hurricane Katrina and some were lost, but the Lafayette Square Conservancy project has been active in restoring their natural beauty. Today Lafayette Square is still a park in the Warehouse/Arts District where one can take a lunch break or just relax on the benches and enjoy the shade. The square is host to "Wednesday at the Square," a free summer concert series featuring top local acts, and to the "Blues and Barbeque" festival in Fall.

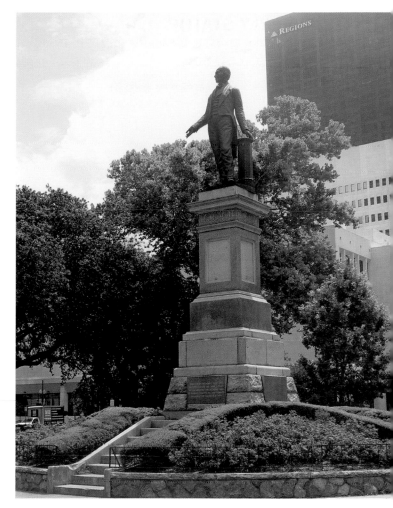

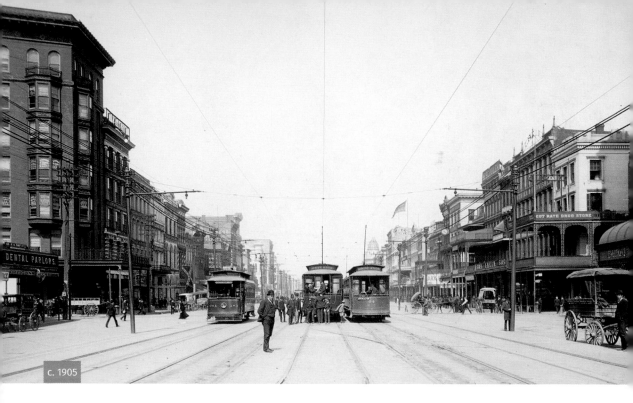

c. 1905

NEW ORLEANS STREETCARS
The oldest streetcar service in the world

ABOVE: Even though the streetcar named Desire—which lent itself to the title of Tennessee Williams's play—was transformed into the less glamorous bus named Desire, New Orleans retains an enduring affection for the streetcar, seen here in its mechanized form in the early 1900s on Canal Street. The city can claim to operate the oldest continuously operating street railway system in the world.

That honor goes to the St. Charles Avenue line, which started as a horse-drawn service from 1835 and went electric in 1893. The Canal Street line, operated by the New Orleans Railroad Company, began service in 1861 and was electrified in 1894. Soon afterward, the Esplanade line was electrified. In 1901 the company extended both lines and connected them together in the Belt Line.

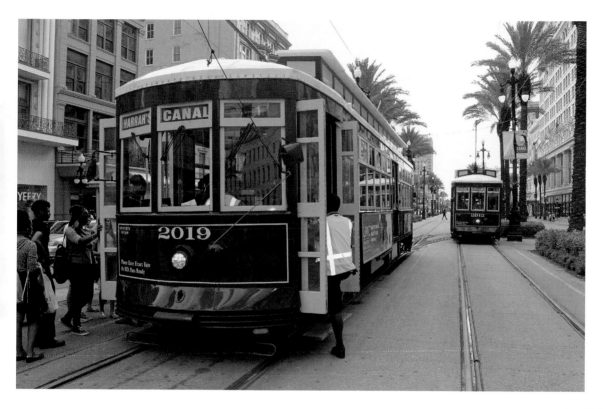

ABOVE: While the St. Charles Avenue line continued through the twentieth century, protected by preservationists who fought hard to give it landmark status, all other streetcar lines were converted to bus service. The distinctive electric streetcars were withdrawn from the late 1940s to the early 1960s when Canal Street lost its cars. Only Hurricane Katrina interrupted the St. Charles line. With the move toward greener technology in the late twentieth century, the streetcars made a comeback, first with a small Riverfront line and then, in 2004, a limited service on Canal Street. The Regional Transit Authority, which is now responsible for the streetcars, has added further extensions on the St. Charles Avenue line despite the intervention of Katrina.

COTTON EXCHANGE
When cotton was king, it required a building that was fit for one

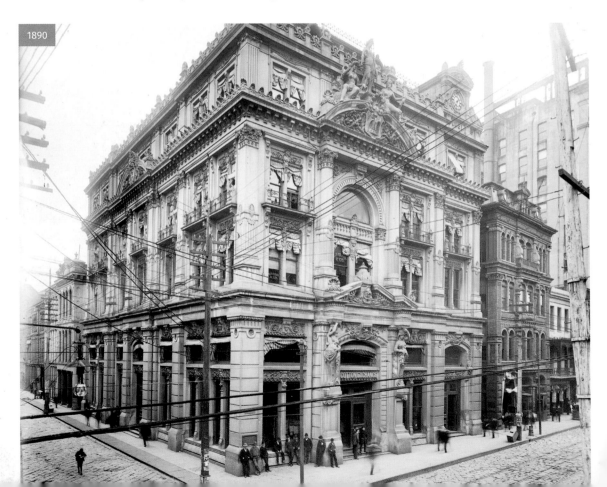

1890

LEFT: Cotton was king in New Orleans in the mid-nineteenth century, and the New Orleans Cotton Exchange Building on the corner of Carondelet and Gravier streets was constructed to promote the cotton trade. The building housed the board of directors and members of various cotton committees that dealt with membership, information and statistics, trade, classification and quotations, finance, credits, and books relating to the cotton trade. Rules and regulations were written here, disputes were settled, and general information was disseminated in this building to all parties dealing in cotton. Mark Twain, visiting New Orleans in 1882, was impressed by what he saw: "When completed, the new Cotton Exchange will be a stately and beautiful building; massive, substantial, full of architectural graces; no shams or false pretences of uglinesses about it anywhere. To the city, it will be worth many times its cost, for it will breed its species."

RIGHT: The replacement Cotton Exchange building of 1920 was designed by the architectural firm of Favrot and Livaudais; however, the trade was already on the wane compared to its nineteenth-century highs. Business dwindled and in 1962 the exchange closed. Still known as the Cotton Exchange Building, it is now a National Historic Landmark and houses a boutique hotel, office space, and retail shops. While cotton is no longer king in Louisiana, it is still a major crop. Louisiana also grows sugar and New Orleans is the place where the process for the granulation of sugar was invented.

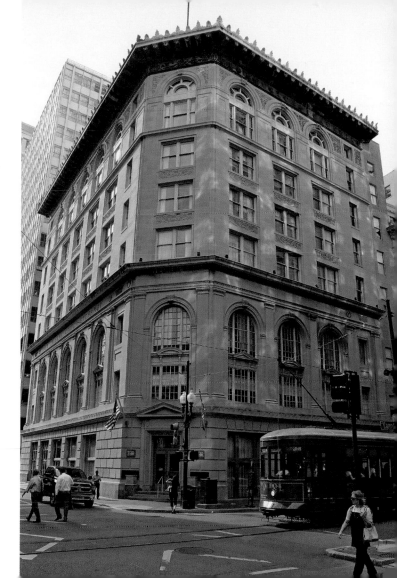

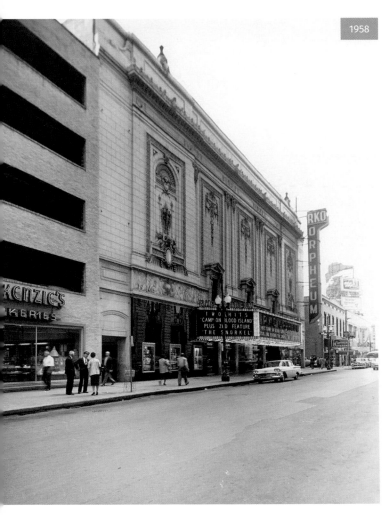

ORPHEUM THEATER
An intimate theater that suffered the tragedy of Katrina

LEFT: This Beaux Arts–style theater was built in 1918 as a venue for vaudeville. The theater is an example of vertical hall theater construction, which was aimed at providing the best sight lines. Later a projector was added and the Orpheum became the RKO Orpheum, a movie theater seating about 1,800. It was a small, intimate theater with a large stage and deep orchestra pit. During the sad days of the Jim Crow laws, the first balcony was set aside for white patrons, and the upper balcony was for "Colored Only."

RIGHT: In the 1980s the Orpheum underwent a complete restoration to become the home of the Louisiana Philharmonic Orchestra (LPO). Sadly, it was devastated by Hurricane Katrina. Floodwaters that filled the theater remained for weeks, ruining the lovely interior. The water level came up to cover all the stage and half the seats. All mechanical equipment in the basement was destroyed. The Orpheum remained closed and dark until 2015 when new owners completed a $13 million restoration. The theater reopened with a performance by the LPO, who are once again the Orpheum's anchor tenant.

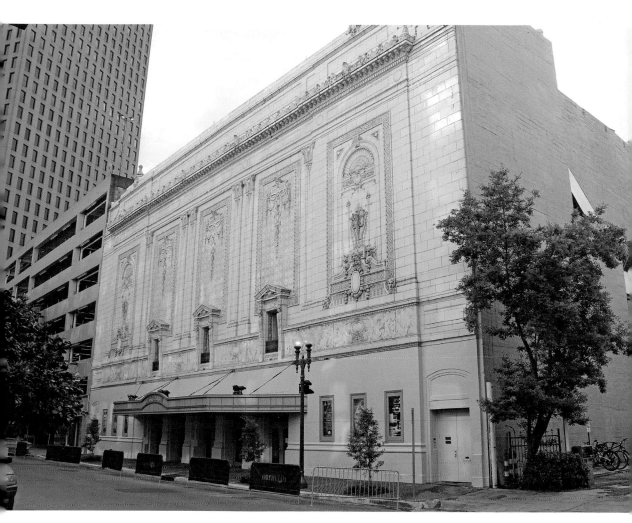

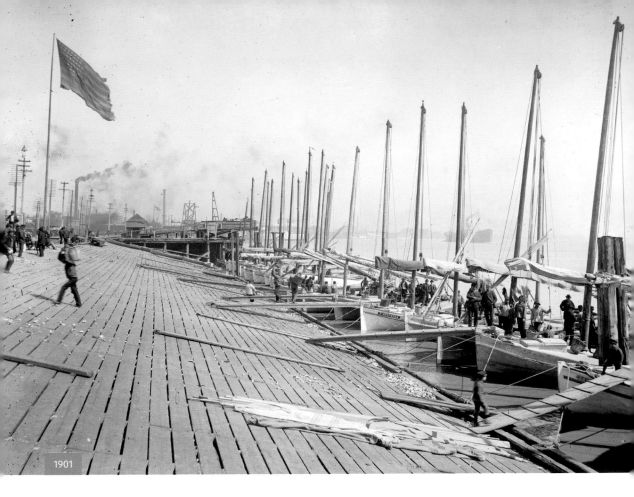

1901

OYSTER LUGGERS AT THE LEVEE
New Orleans has long enjoyed a love affair with the Louisiana oyster

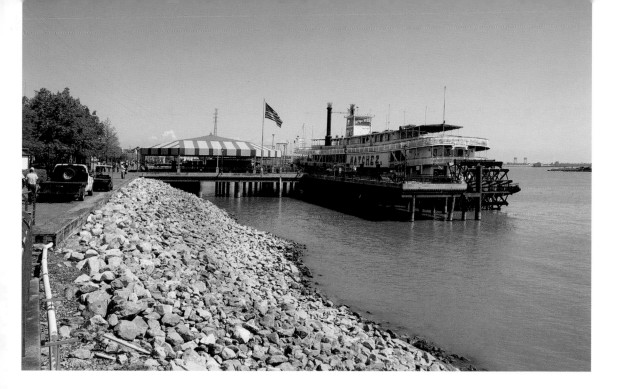

LEFT: This photo shows oyster luggers landing on the riverfront between St. Phillip and Hospital (now Governor Nicholls) streets. In the nineteenth century, oyster luggers, specially designed boats with open deck space for oyster storage, would dock and sell their catch to a welcoming crowd. The oyster fishermen used hang tongs to harvest the oysters from the riverbed. The luggers had plenty of walking space along the sides and stern to allow for the operation of these tongs. Oystermen would signal their arrival at the wharves by blowing on conch shells. Oyster fishing was hard work done by the young and hardy.

ABOVE: Oyster fishermen would lease oyster reefs or water bottoms from their local parishes, on which they had the rights to harvest the shellfish. These rights were transferred to the State of Louisiana in 1902. Back then, they would sell oysters for around $3 to $4 a barrel. Today oysters are harvested year-round using the "dredge" method invented in 1905, but they are no longer landed on the levee. New Orleans has always had a love affair with oysters. They are served raw in the half shell, charbroiled, cooked as oysters Rockefeller, oysters Bienville, in soup, and just about any other way you can come up with.

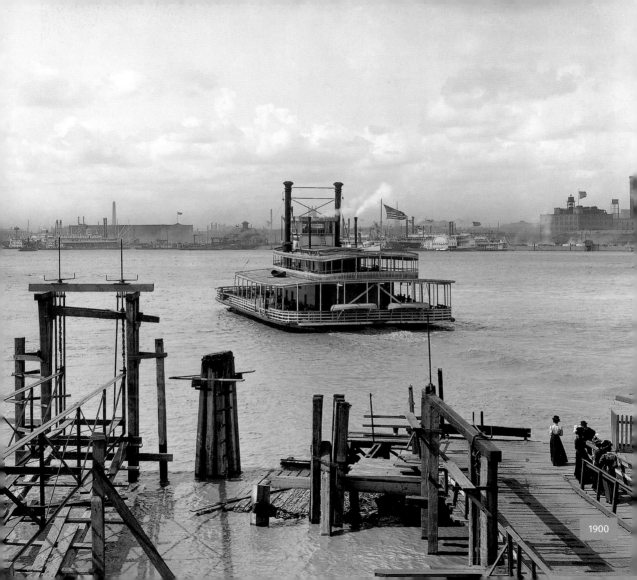

1900

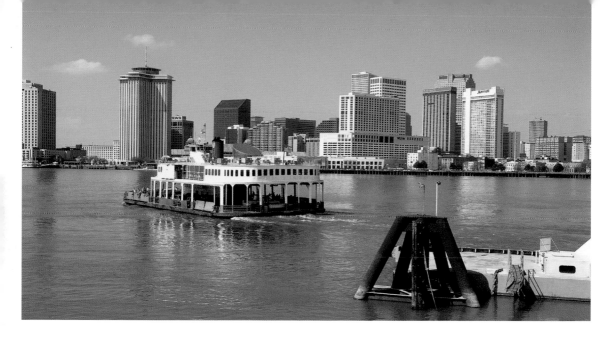

ALGIERS FERRY LANDING
Steam has been replaced by diesel, but the journey is still the same

LEFT: The Mississippi River is the reason New Orleans exists. The river was the main "highway" through America in the 1700s when New Orleans was founded. Algiers was part of the land grant given to New Orleans founder Jean-Baptiste Le Moyne by the Company of the Indies in 1719. It became a thriving municipality on the west bank of the river and was absorbed into the city of New Orleans in 1870. A steam-driven ferry shuttled passengers and goods between the banks in 1900, as shown left. In its heyday, Algiers had six ferries working to New Orleans's east bank, including one ferry capable of shuttling railroad cars.

ABOVE: New Orleans still spans both banks of the Mississippi River, and the need for the Algiers ferry continues. The ferry is now driven by diesel engines and transports pedestrians and automobiles across the river every hour. The ferry ride provides panoramic views of the skyline of New Orleans. On the Algiers side of the ferry you will find the Point, a neighborhood that still has the feel of a village with corner stores and neat houses with gingerbread trim.

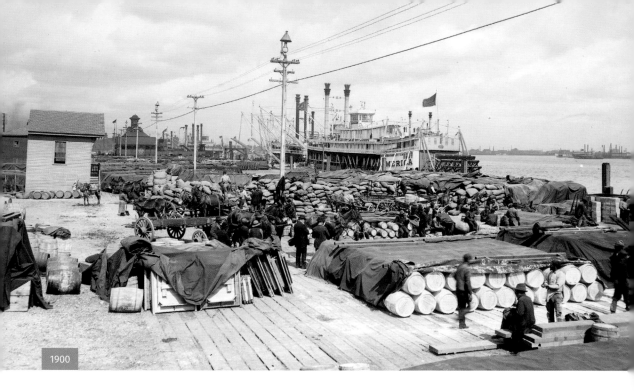

1900

LEVEE AT FOOT OF CANAL STREET
In the age of the steamboat, no place in New Orleans was more busy than the levee

ABOVE: The levees were necessary in order for the French to build New Orleans. The Mississippi River was, and still is, unpredictable and has been known to jump its banks. The levee at the foot of Canal Street was a major site for river trade. It was the site of numerous warehouses and industrial wharfs, as well as floodwalls. This area remained basically utilitarian until the late 1980s. Wharfs for the

loading and unloading of ships from all over the world were constructed on the river in front of the Vieux Carré and spread up and down the river. Cotton and sugar left from the ports and coffee and tropical fruit came in to be sent at first by steamboats and then by railroads around the country. This photo from 1900 shows the levee as it looked when steamboats had the luxury of mooring side-on.

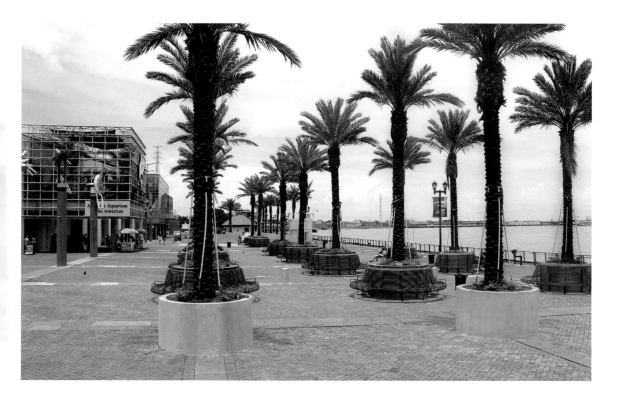

ABOVE: The levee has been reimagined as Woldenberg Park and is operated by the Audubon Institute. The Audubon Aquarium of the Americas, which opened in 1990, can be seen on the left. Named for philanthropist Malcolm Woldenberg, the park is sixteen acres of green space in the French Quarter. Beginning at Canal Street and the Aquarium of the Americas, it continues down to the "Moonwalk" (named in honor of former mayor Maurice Edwin "Moon" Landrieu) across the street from Jackson Square. Woldenberg Park has several notable sculptures, including the city's Holocaust Memorial and the Monument to the Immigrant. This area is not used as it was a century ago. Now the area is home to river boats docked and ready for a nostalgic trip on the mighty Mississippi River. It is no longer a place where dockworkers spend long, hard hours loading and unloading.

POYDRAS STREET WHARF

Where ships unloaded a steady stream of coffee from Latin America

1903

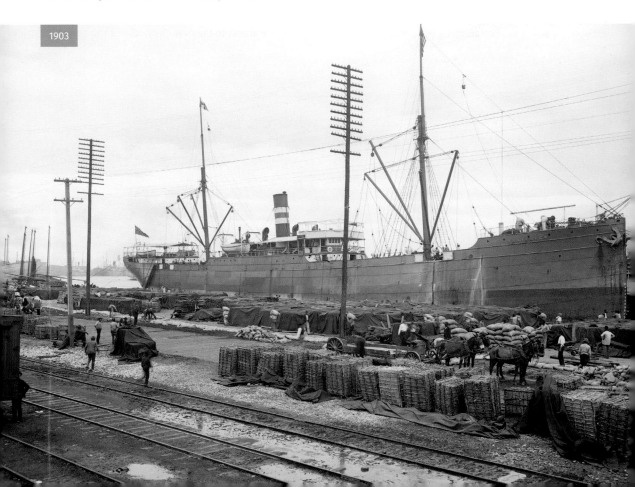

LEFT: Poydras Street Wharf was once bustling with activity, as these photos show. By the 1920s, this wharf was the central receiving point for the coffee industry. Coffee arrived in 130-pound bags that had to be carried by hand by the dockworkers. In the early twentieth century, the system was mechanized, replacing the need for much of the manual labor that had previously been employed along the river. Although coffee was the main import unloaded at this wharf, bananas and other tropical fruit from Latin America were typical cargoes at what was one of the major wharfs in New Orleans.

BELOW: Today, this area along the river is a pedestrian walkway outside of the Riverwalk Mall filled with shops and restaurants. Although New Orleans is still one of the largest ports in the United States, its expansion up and down the river from the original Vieux Carré has allowed more leisure access to the river. Today, cruise ships rather than coffee boats are docked at the Poydras Street Wharf. The twin cantilever bridges—named the Crescent City Connection—were built in 1958 to connect the east and west banks of the Mississippi River.

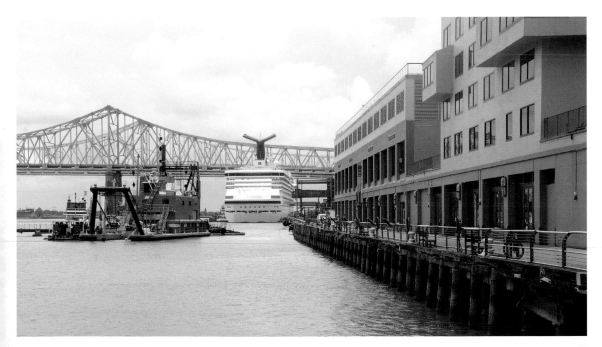

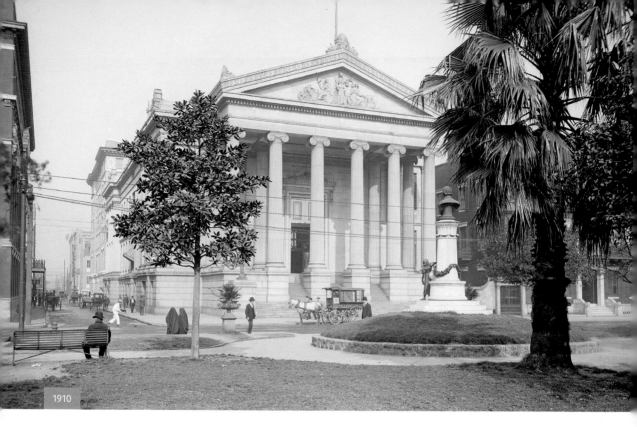

1910

CITY HALL / GALLIER HALL
A place of reverence for supporters of the South; Jefferson Davis lay in state here

ABOVE: This photo shows the old City Hall that was built between 1845 and 1853, and which served as the seat of government until the 1950s, when it was moved to a new building on Poydras Street in the Central Business District. When it was built, the Creole French did not welcome the Americans, and New Orleans was divided into three municipalities. This Greek Revival building was originally headquarters for the Second Municipality, and ultimately became New Orleans City Hall. It is also called Gallier Hall in honor of its renowned architect, James Gallier Sr.

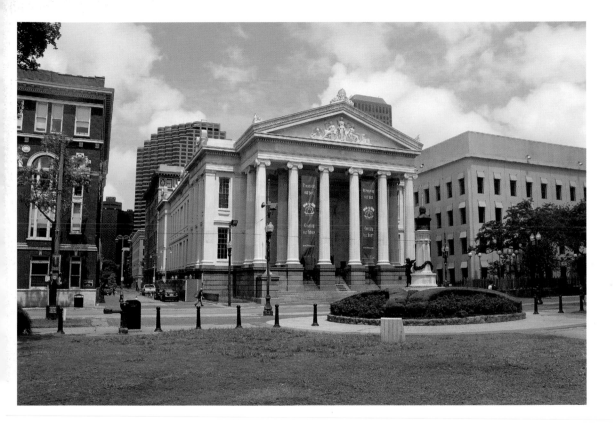

ABOVE: No longer referred to as City Hall, Gallier Hall has seen many historic events since its construction. It was the site of numerous major events over the years. Jefferson Davis and General P. G. T. Beauregard, and even Ernie K-Doe, a New Orleans music legend, lay in state here. It is the place where Rex toasts the mayor on Mardi Gras Day, and its elegant setting is the site of many major political and private functions. Across the street is Lafayette Square, a green space in the Central Business District. The statue of philanthropist John McDonough, who divided his fortune between New Orleans and Philadelphia for the construction of public schools, can be seen in both photos.

ALSO AVAILABLE **400-page Then and Nows**

ISBN 9781909108653

ISBN 9781909108660

ISBN 9781862059955

ISBN 9781862059948

ISBN 9781911595144

ISBN 9781910904817